A Taste of Art
LONDON

HOLLY
GROTHE HOWARD

JACQUELINE
COCKBURN

A Taste of Art

LONDON

1 CITY · 10 MUSEUMS · 100 WORKS OF ART

ILLUSTRATED BY
FELICITY PRICE-SMITH

UNICORN

This book is dedicated to all the gallery
attendants who, with such goodwill
and care, help us find our way around.
Please ask them for guidance as you
enjoy a taste of London's art.

How to use this guide

Art museums and galleries can be warm and inviting spaces, but also sometimes daunting. Whether you are visiting London for the first time or live locally, your well-meaning aims to see the collection begin to fade as museum fatigue sets in. Your back aches, your head spins, you simply stop looking and perhaps leave feeling slightly overwhelmed. We don't want you to feel exhausted by your visit, but rather to feel engaged and empowered.

A Taste of Art invites you to take a comfortable and enjoyable tour around ten of London's magnificent art galleries and museums. Your journey begins with art from an emerging Britain at the British Museum, progressing through the centuries via the Royal Academy's permanent collection, which explores how the art of the past influenced the art of the future, before concluding with contemporary portraiture at the National Portrait Gallery. The Latin for 'to taste' – *sapere* – is also 'to know'. In essence not only to look at but also to see, understand and indeed savour one hundred great pieces of art.

Ponder the quotation ⌇ to whet your appetite and then search for the KEY INGREDIENT that unlocks each work and aids consumption. Each TASTING NOTE is designed to give you just enough of the essential flavour of the work and leave you salivating for more.

We recommend you find the works we suggest, but by all means have a look around. If a piece is not in the collection because, due to the museum or gallery's generosity it is on loan elsewhere, we hope you will understand and make a mental note to come back another day.

We hope these narrative insights leave you with a good aftertaste and you will look out eagerly for the next *Taste of Art* in the series.

Bon Appétit!

AN EMERGING BRITAIN

THE

Some of the greatest pieces of art in the world are housed within the walls of this national treasure. The British Museum was opened in 1753 with the mandate that free admission would be granted to 'all studious and curious persons' by Sir Hans Sloane, who bequeathed his collection of some 71,000 objects to King George II. His descendants were to be paid £20,000, which was accepted by an act of parliament on 7 June 1753 and the museum opened to the public on 15 January 1759. The Queen Elizabeth II Great Court is two acres in size and the largest covered public space in Europe. In this national treasure, explore the lives of the Emerging Britains during and after the Roman occupation, through their writing tablets, pottery, helmets, statues and other objects.

GREAT RUSSELL STREET, LONDON WC1B 3DG
www.britishmuseum.org

ONE
BRITISH MUSEUM

VINDOLANDA TABLETS

AD 85–130

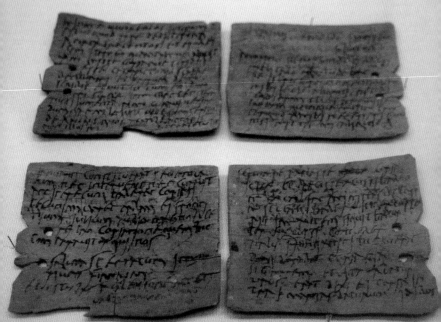

Key ingredient:

TABLET 291

CAST YOUR EYE along this set of tablets with their ink lettering written on local wood from birch, alder and oak tree. The ink is made from gum arabic, carbon and water, and the script is cursive. The tablets were found in 1973, close to where Hadrian's Wall would later be built; surviving only because they were buried in water-logged ground.

oldest surviving handwritten documents in Britain. Look intently and you will find one of the earliest known examples of writing in Latin by a woman, Claudia Severa, the commander's wife, inviting Sulpicia Lepidina, to a birthday party. The letter is warm, and she calls her friend, 'sister, my dearest soul', possibly referencing

'On 11 September, sister, for the day of the celebration of my birthday, I give you a warm invitation to make sure that you come to us, to make the day more enjoyable for me by your arrival, if you are present.' - CLAUDIA SEVERA

They are letters mostly from soldiers garrisoned at the Fort of Vindolanda. You are looking at a selection of these, in all, 500 letters, and you cannot fail to be moved by these documents which are some of the

a knowledge of Virgil. Other letters record military matters, requests for more beer, leave requests and even soldiers asking for socks and underpants. It is a vivid insight into life in Roman Britain.

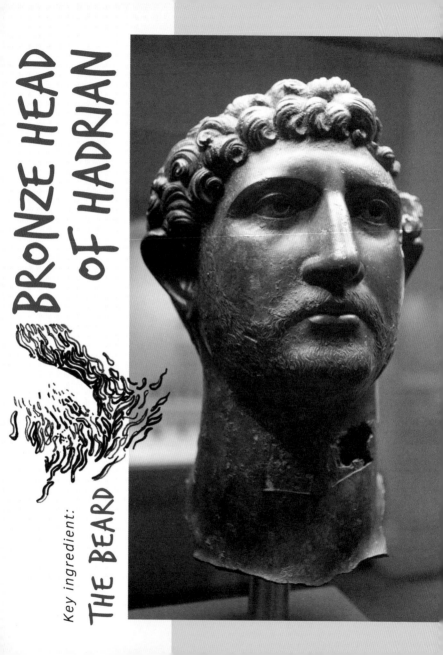

BRONZE HEAD OF HADRIAN

Key ingredient:

THE BEARD

STARING AT YOU is Emperor Hadrian, larger than life and sporting a curly, wispy beard and a moustache. Beards consequently became a popular trend in the Roman Empire. Hadrian is about 30 years old here and by this time had built the wall stretching 80 miles across Britain, separating the 'barbarians' from the Romans. This bronze head, weighing about 16 kilos without the block and hollow cast in the round, was part of a statue which may well have stood in Roman London, commemorating his visit to Britain in AD 122. Separated or hacked from the body by indigenous Britons who opposed the idea of a deified emperor, this head was found in the Thames in 1834, with other small statues and gold coins, suggesting perhaps that the statue had stood on the bridge the Romans constructed over the river. Hadrian's eyes are wide set and his ears are large; an imposing presence who had established borders, travelled throughout the empire, controlled his frontiers and rebuilt cities.

'Small vulnerable wandering soul, guest and companion of my body. Now you have to descend into pale, stern and hard places, where you renounce the joys of before.'

– ATTRIBUTED TO EMPEROR HADRIAN

RIBCHESTER HELMET

FIRST–SECOND CENTURY AD

Tasting notes

THIS IS CLEARLY not a bronze helmet which would be worn in battle, as it would not have protected its wearer. Instead, it was used for cavalry sports, showcasing élite sportsmanship highly valued by the Romans, for whom braveness and fearlessness went hand in hand. According to accounts by Arrian of Nicomedia, a Greek historian appointed by Hadrian as legate of Cappadocia, only soldiers of high rank would wear such a decorated and heavily embossed head piece. These colourful displays would entertain the troopers as well as training the rider, although the helmet might have proven to be heavy on the head when riding.

The visor or face mask at the front would be attached to the helmet by a leather strap. The helmet is decorated with a scene of a skirmish between infantry and cavalry, perhaps Greeks and Amazons, and many of them raise their weapons and protect themselves with shields which they brandish in the air. Found in 1796 by a clog-maker's son playing in Ribchester, this is part of a hoard of corroded metalwork, including military equipment and awards.

'Fear is proof of a degenerate mind.'
– VIRGIL

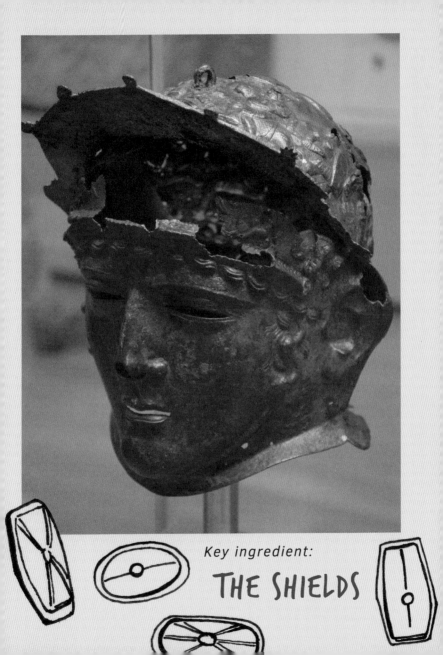

Key ingredient:

THE SHIELDS

Key ingredient:

THE STUBS ON THE HEAD

ULEY MERCURY

SECOND CENTURY AD

Tasting notes

CARVED IN LOCAL Cotswold stone and found in Uley, Gloucestershire, we must imagine that in Roman times this head of the god Mercury would not only have belonged to a larger-than-life-sized body but would also have been painted. It's not too hard to imagine the colours and then begin to see the expression on this attractive, calm face, particularly in the eyes and lips. Look carefully at the curly hair and you will find small stubs, which indicate the existence of wings. Found on a once-religious site, as part of a temple to Mercury, surrounded by living quarters, guest accommodation and shops, it looks as though this cult statue of the god, patron of financial gain, commerce and eloquence, was once destroyed but then preserved by someone who carefully and respectfully buried it. It was buried in the post-Roman period beneath a cobbled platform, only to be found in 1979, along with fragments which indicated the body and a base with a ram and a cockerel on it.

'Tiny wings of gold were projecting from his locks, in which they had been fastened symmetrically on both sides.' – APULEIUS

CORBRIDGE LANX

FOURTH CENTURY AD

Tasting notes

THIS MAGNIFICENT SILVER platter with a scene from Apollo's shrine, possibly on the Greek island of Delos where he was born, was found in 1735 in Corbridge, in the north of England not far from Hadrian's wall. Found in the bank of the River Tyne, it is uncertain where it was manufactured. The term 'lanx' means tray and was used by eighteenth-century scholars. If the Delian shrine is depicted, then the older woman sitting spinning may be Leto, the mother of Apollo and his twin sister Artemis who enters from the left and is clearly in conversation with the helmeted Athena who raises her right hand in greeting. In the foreground stands an altar flanked by Artemis's hound, a fallen stag and a griffin, a mythical beast associated with Apollo who is at the entrance to the shrine and carries his bow. You can observe the lyre at his feet, suggesting he has been playing before his sister's entrance. The scene with figures which seem to engage with one another is very animated, beautifully composed with the animals in the foreground and the tree in the background forming a sense of depth and perspective.

'Wilt thou have music?
Hark! Apollo plays and twenty caged
nightingales do sing.' – SHAKESPEARE

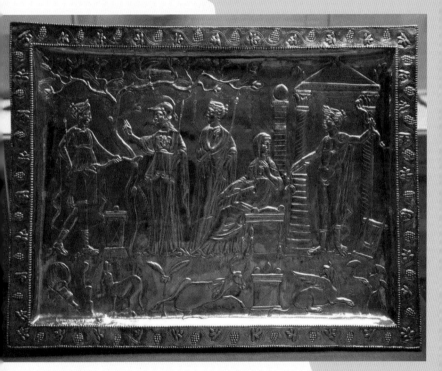

Key ingredient:

THE LYRE

HOXNE PEPPER POT

THIS SILVER PEPPER pot (*piperatorium*) in the shape of a torso of a dignified, elegant and educated Roman lady, was found in Hoxne, Suffolk in 1992. It is one of four, found buried alongside coins and other objects before the family fled during the phased withdrawal of Roman Britain. Her hair is elaborately styled, parted in the middle with rolls at the side and locks at the back which are twisted and put up with hairpins. This hairstyle and the scroll she points at, is enough to suggest her high birth, education and the family's wealth as they flee for their lives, not knowing whether they will return to recover their treasures. We can imagine this pepper pot with its gilding, glinting and flickering in the candlelight at a Roman celebratory meal. Pepper, brought over on the early trade routes from India and used liberally by wealthy epicureans, was highly valued as one of the spices used by the Romans to make them sweat in order to cool down and titilate their taste buds. This pot has a sophisticated mechanism on the base which could be turned to three different positions: to close the pot, to reveal a large hole to enable filling the pot with pepper and a group of small holes for sprinkling.

Key ingredient:

THE HAIRSTYLE

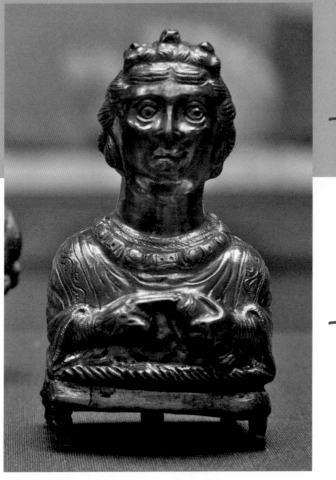

'The pot bubbles, friendship lives.' – ROMAN PROVERB

HINTON ST MARY MOSAIC

THIS SECTION OF a mosaic floor, discovered in 1963, made with local Dorset materials – red, cream and yellow tiles set in cement – was probably once in a Roman villa in the village of Hinton St Mary. The mosaic

EARLY FOURTH CENTURY AD

This is the central roundel of a ...
mosaic floor from a ...
Dorset. It ...

} 'in this sign, thou shalt conquer.'
– EUSEBIUS OF CAESAREA

covered two rooms and it is unsure what the space was used for, although it might have been a dining room or a house church. If you were to walk across the floor in Roman times you would also see hunting scenes, and in one of the rectangular panels, the god Ballerophon mounted on Pegasus spearing the Chimera. Then your eye might be caught by a young man with a monogram, flanked by pomegranates. Perhaps inspired by a coin head of the emperor Magnentius, he wears a tunic and his hair is elaborately styled. Unshaven, he seems to stare back at you with a piercing glance. Only when you decipher the letters do you realise who he is. This is one of the earliest depictions of Christ, as the monogram reads 'Chi Ro', forming the first two letters of the Greek word for Christ. First used by Constantine the Great who had converted to Christianity in AD 312, making the religion legal, the letters replace any other obvious sign that in this villa, the wealthy occupants displayed their faith.

Key ingredient:

THE GREEK LETTERING

MILDENHALL GREAT DISH

FOURTH CENTURY AD

Key ingredient:

HEAD OF OCEANUS

WHEN PLOUGHMAN GORDON BUTCHER and his employee Sydney Ford unearthed the Mildenhall treasure in 1942, we can only begin to imagine how it looked on the sideboard or mantlepiece at Ford's home. This dish, weighing more than 8 kilos, was used by Ford, along with other utensils for special occasions with his family and we can merely speculate over both men's awareness of the significance of the find; one of the most important collections of late-Roman silver tableware from the Roman Empire. This great silver dish, also known as *Neptune* or *Oceanus*, due to the image of the sea god in the centre, is a magnificent example of Bacchic imagery, possibly buried in the fourth century during a time of unrest as The Empire gradually broke up. Probably owned by a wealthy Christian, Oceanus is shown full face with a beard made of seaweed and dolphins coming out of his hair. He is surrounded by decorative pagan friezes featuring naked sea nymphs and tritons. The outer frieze depicts Bacchus on his panther holding grapes, a mask of Silenus above Oceanus, the goat-legged god Pan brandishing his pan pipes and a drunken Hercules. This is the worship of Bacchus and his triumph over Hercules.

'Here burning Bacchus rules tonight!'

– CATULLUS

IT ALL DEPENDS on light. The translucent glass in this dichroic fourth-century Roman glass cage-cup, perhaps made in Alexandria or Rome by a talented lapidary, has a green colour if you look at it from the front in the reflected gallery light but turns purple-red when lit from inside or from behind, due to colloidal silver and gold particles in the glass. Glass blowing was popular, but very few of these cups survive. Perhaps the colour change from green to red suggests the maturation of grapes, fitting for depictions of Bacchus. Unusually, there is a composition with figures, showing the mythical mad King Lycurgus, who (depending on the version) tried to kill Ambrosia, a follower of the god Dionysus (Bacchus to the Romans), who he had also attacked. She was transformed into a vine that twined around the angry king, restraining and eventually killing him. Due to the colour changes, Lycurgus seems to glow with rage. Flanked by Ambrosia and a satyr hurling a rock on the left, and on the right Bacchus accompanied by Pan and a faceless panther, companion of Bacchus, perhaps the scene references the eventual defeat of Emperor Licinius in AD 324 by Constantine.

'And after this he [Lykourgos (Lycurgus)] drank beer thinned by age and made thereof loud boast [against Dionysos] in the banquet-hall.' – AESCHYLUS

LYCURGUS CUP

FOURTH CENTURY AD

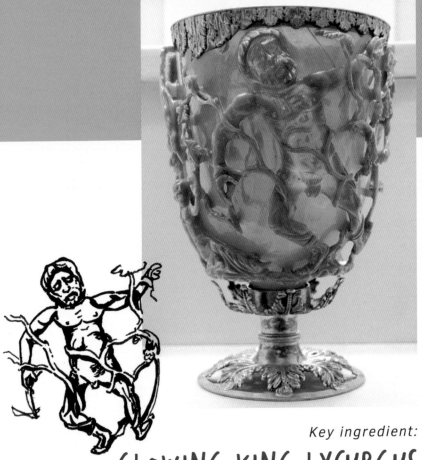

Key ingredient:

GLOWING KING LYCURGUS

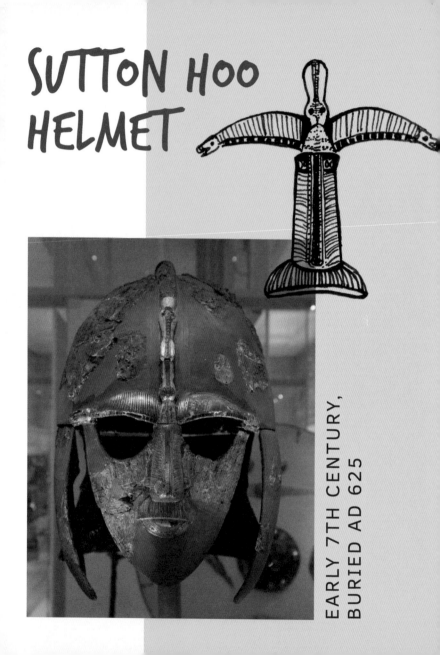

SUTTON HOO HELMET

EARLY 7TH CENTURY, BURIED AD 625

THE DRAGON MOTIF

FOUND ON 28 July 1939, thanks to Edith Pretty who lived nearby, this decorated iron and tinned-copper alloy helmet, possibly a family heirloom, had been part of arguably one of the most extraordinary hoards ever found in Britain, which included gold jewellery, coins and silver. Buried in a 27-metre ship in an earthen mound in Suffolk, it had shattered into pieces, possibly caused by the collapse of the burial chamber. You are looking at the reconstruction and a replica nearby, to understand the spectacular wealth. Note particularly the dragons, especially the winged one which forms the face, eyebrows, nose and mouth piece or moustache. Probably worn in battle, the Anglo-Saxon warrior would have looked sinister and his voice sounded menacing and frightening, whilst the nostrils allowed him to breathe. The Scandinavian design is influenced by Roman models, including dancing, mounted and fallen warriors. This and the use of precious materials such as garnet, silver and gold, indicate that the status of its owner was high. He may have been Raewald, the ruler of East Anglia, buried with a superb collection of worldly goods. Perhaps he died in battle wearing this extraordinary glittering face piece.

'To guard his head he had a glittering helmet
That was due to be muddied on the mere bottom
And blurred in the up swirl.' – BEOWULF

Cromwell Road
London
SW7 2RL
www.vam.ac.uk

2. Victoria and Albert Museum

Over the main entrance to the Victoria and Albert Museum are the words of Sir Joshua Reynolds, 'The excellence of every art must consist in the complete accomplishment of its purpose.' Established in 1857, it was later renamed the V&A in 1899 when Queen Victoria laid the foundation stone of the current building. The first director of the museum, Henry Cole wanted to attract a wide audience and said, 'the evening opening of public museums may furnish a powerful antidote to the gin palace!' The first gallery café in the world was also the brainchild of this progressive museum director. Enjoy the range of magnificent Medieval works, both sacred and secular, which help us to understand how people found ways of expressing their faith in a Spiritual World. Don't miss stopping in the cafe for a cup of tea and to feast your eyes on the beautiful walls.

'I am the true vine...' - John 15

⑧

The Easby Cross

This fragment of a monumental free-standing, sandstone cross without its arms was built into the fabric of Easby Church in Yorkshire, although the stone matches that found in the Aislaby quarries of Eskdale near Whitby, 60 miles away. Unique to the British Isles and Ireland, it is an excellent, early Anglo-Saxon example. Four fragments were repaired with molten lead. They are beautifully restored to display the carving with decorative and figurative motifs. Start by finding Christ in Majesty on the front face. He holds a book and with His raised right hand He gives a blessing. At His feet is a halo of a lost figure and below that are the faces of many of the apostles. On the back face is another Christ and a beautiful interlocking vine scroll – a common motif on monumental crosses, perhaps a connection with foreign artists from the East, possibly through the scholar Alcuin of York and Carolingian art from the Frankish Empire. Christianity flourished in the North Kingdom despite political turmoil at this time. Pause to look at the beasts amongst the vine, which is contained by rope work, and you will find a bird pecking at a bunch of berries (or grapes?) and an equine beast below it. It is characteristic of Celtic spirituality to see the Holy in the everyday natural world.

Key ingredient: The Vine Scroll

Casket 961-5

This ivory casket, decorated and finely carved with scrolls, stylised plants and floriated kufic script was made for the daughter of Abd al-Rahman III, who was an Umayyad Emir and ruler in Al Andalus during the tenth century. He declared the Caliphate of Cordoba in 929, making himself Caliph; the political and religious leader of all Muslims in the country. He moved his court to Madinat Al-Zahra, outside Cordoba, and built a palace which was sacked in 1031 and is now a World Heritage Site. Objects such as this, had great value at the time and as a gift to his daughter it indicated favour, although as the prayer inscribed around the lid was only said upon his death, this implies the casket was made in or after 961 as a memory of him. The decoration itself was mirrored on the walls of the palace, suggesting central control of decorative arrangements. We can only imagine what she used it for – oils or perfumes or possibly jewellery – and it is important to remember that the court at the time, which was rich, cultured and powerful, would contain many such objects of value and beauty.

Tasting notes

Key ingredient: The Inscription

'In the name of God,
the Compassionate, the Merciful.
This is what was made for the
daughter, the lady, the daughter
of Abd al-Rahman, Commander
of the Faithful, may God's mercy
and favour be his.'

– The inscription on the casket

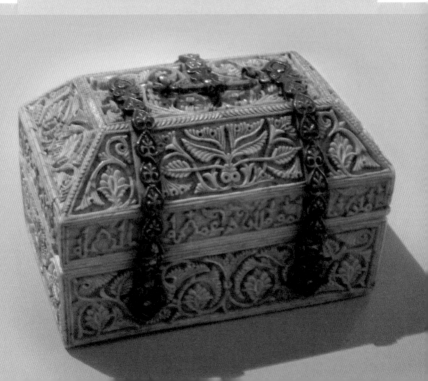

Tabernacle c. 1180

This beautiful tabernacle is made from gilded bronze and copper with champlevé enamel on an oak core; it also has walrus and elephant ivory figures and reliefs. It is a wonderful example of the art of goldsmiths during the last half of the twelfth century in Cologne. The object is in the form of a miniature domed church of Greek cross design, supported by four gilt-copper griffins which seem to elevate it to another world. During recent conservation a hidden note was found inside, stating that it came from a Benedictine monastery in Cologne, probably that of Saint Pantaleon. Previously considered a reliquary, it is now suggested that it probably held the Eucharist. The ivory panels depicting biblical scenes and champlevé plaques with floral and decorative geometric designs hide a wooden core beneath and with dendrochronological analysis it was proved that the tree was felled between 1148 and 1158. Some of the ivory panels are more recent but this piece is mostly medieval. Christ and eleven apostles are seated round the dome, with sixteen figures of prophets below who hold inscribed scrolls. Four ivory plaques depict the Virgin and Child with St Joseph, the Journey of the Magi, the Crucifixion and the Holy Women at the Sepulchre.

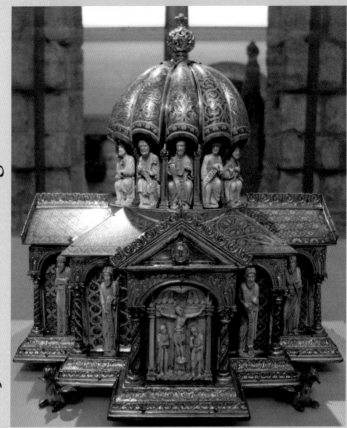

'And Simon Peter answered and said, Thou art the Christ, the Son of the living God.'
– Matthew 16:16

Key ingredient:
The Griffins

'Above it stood
the seraphims: each one had six wings;
with twain he covered his face,
and with twain he covered his feet,
and with twain he did fly.'
– Isaiah 6:1–3

The Syon Cope

1310–20

Tasting notes

From the twelfth to the fifteenth centuries, England was renowned for the quality of its handmade luxury embroideries, often called *Opus Anglicanum*. This practice came to an end with Henry VIII's Reformation in the 1530s and garments were hidden or cut up. This beautiful example was probably a chasuble, the vestment worn by priests for the celebration of mass, but was converted, probably by nuns in exile, into a smaller cope worn for various ceremonies. It takes its name from the Bridgettine convent in Syon, Middlesex. The linen is embroidered with silk, silver-gilt and silver thread in underside couching with split, cross and plait stitches and laid and couched work. It contains scenes from the Life of Christ and the Virgin, with standing apostles. We can see the Coronation, Burial and Death of the Virgin on a, now faded, red ground. Look, too, for St Michael overcoming Satan, Christ appearing to Mary Magdalene and the incredulity of Thomas. Of note, in between the green and red grounds of quatrefoils, are six-winged seraphs, a type of celestial or heavenly being originating in Ancient Judaism but playing a role in Christianity, Judaism and Islam.

Key ingredient:
Six-winged Seraphs on Wheels

The Saint Denis Missal c. 1350

'And anon the body of Saint Denis raised himself up, and bare his head between his arms, as the angel led him two leagues from the place, which is said the hill of the martyrs, unto the place where he now resteth, by his election, and by the purveyance of God.'

– *The Golden Legend*

Tasting notes

This is one of the finest examples of a fourteenth-century Gothic manuscript. It contains all the text, chants and music for the celebration of mass by the priest and the choir. It was probably intended to be used at one of the altars at the important Abbey of Saint Denis just north of central Paris. The exact dating of this work is facilitated by the calendar at the beginning of the manuscript which records the death of the abbot Guy de Chartres but not of King Philip VI who died six months later, so it would have been created between February and August 1350 by accomplished illuminators such as The Remède de Fortune Master. It is made of very thin foliation parchment, ink, pigments and gold, and is leather bound, probably later, over boards. Many illuminations depict the life of Saint Denis, the patron saint of France, and the consecration of the Abbey. If you flick through the pages on the screen nearby you will find the martyrdom of the saint, kneeling in prayer with gold scrolls before he is beheaded. Look, too, for birds, grotesques, insects and other narrative scenes.

Key ingredient:

The Martyrdom of Saint Denis

These stained-glass panels were commissioned by William of Wykeham, who was Bishop of Winchester (1366–1404) and founder of Winchester College in 1382. They were made in the workshop of Thomas of Oxford, who was an important glazier at the end of the fourteenth century, from clear, coloured and flashed glass with painted details and silver staining. The contract for the windows, to decorate educational establishments such as Winchester College and New College, Oxford, is discussed in a document of this date. The three lights, although probably originally not next to each other, were located near the windows of the altar of the Chapel of Winchester so that daylight would stream into the chapel through them. They were part of a larger arrangement of twelve apostles and prophets. All three figures stand beneath canopies. The prophet Ezekial, who exists in Judaism, Christianity and Islam, stands on a base which has 'Sophonius' erroneously written on it. His robes flow around him with extraordinary three-dimensionality. The mistake was probably made when the glass was removed in 1825 and replaced by copies in the chapel, but these are the originals.

'I will give you a new heart and put a new spirit in you; I will remove from you your heart of stone and give you a heart of flesh.'

– Ezekiel 36:26

Prophet Ezekiel flanked by Saints John the Evangelist and James the Less

c. 1393

Key ingredient:
Ezekiel's Robes

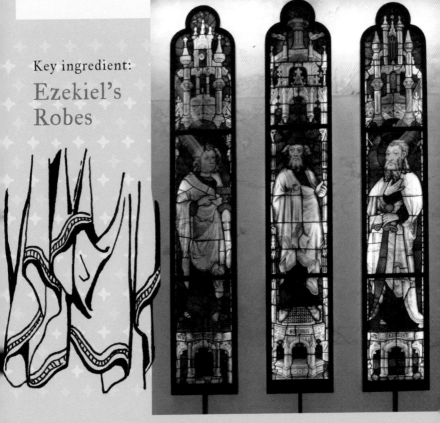

'With the merciful
You will show yourself merciful...'
– 2 Samuel 22:26

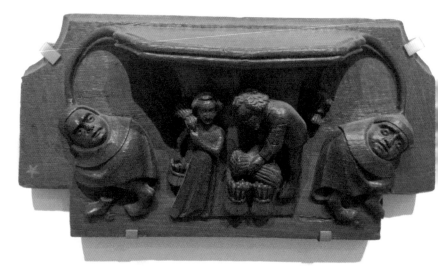

Key ingredient: A Blemya

Misericords with Harvest Scenes

1375–1400

Tasting notes

Take a peep at these misericords, so called because they took mercy on the monks who had to stand for long hours at prayer and song without being seen to sit. They could perch on these seats and take the weight off their feet. Set on the underside of hinged seats at just the right level for this purpose and carved out of a solid, rectangular piece of oak, they are frequently inventive and rarely religious in their subject matter. Perhaps the monks were unsure about sitting on overtly religious scenes. In these examples we have harvest scenes: 'stoking' sheaves of corn flanked by pygmies, threshing corn flanked by blemyae (headless, man-eating creatures – well-worth finding) and carting corn flanked by booted, armless hybrid monsters. The grotesques give us an insight into the monks' fears perhaps. These scenes appear humorous and at times daring, and probably only survived the Reformation because they were hidden. They were likely carved in East Anglia and reference every day life and work; the labours of the monks which contributed to the production of food. It is not known which church they were made for.

Devonshire Hunting Tapestry
Boar and Bear Hunt

This slit tapestry with a floral background is one of four owned by the V&A. Probably made in Arras, it depicts hunting scenes (a popular pastime) with participants wearing elaborate court dress typical of the Burgundian Court of the latter half of the 1420s. The hunting of the boar is on the left and bear on the right. The figures' poses are typical of the languid style of International Gothic. Note the high-waisted gowns and the heart-shaped headdresses. The woman in

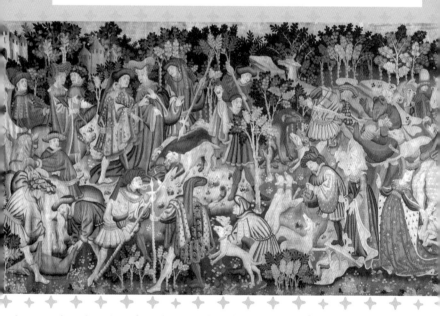

the centre, for example, wears a pink dress lined with miniver, an expensive fur obtained from the bellies of Baltic squirrels. This kind of lining would have required hundreds of skins, taken from squirrels which were killed during the winter months. She rewards a dog with food. Some of the sumptuous gowns bear mottos and all suggest that this is the pastime of the nobility. These tapestries were made for the insulation and decoration of large halls and castles, some of which can be seen in the distance. These were at Hardwick Hall in Devonshire until 1899 and are woven in bright mostly pastel colours in wool warp and weft.

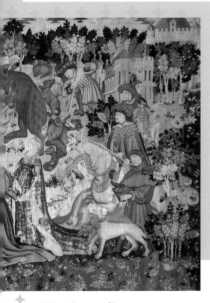

'Destiny itself is like a wonderful wide tapestry in which every thread is guided by an unspeakable tender hand, placed beside another thread and held and carried by a hundred others.'
– Rainer Maria Rilke

Key ingredient:
The Woman Feeding the Dog

Three Figures from Naworth Castle

These three English, oak, standing figures represent various categories of nobility; a knight in South German 'gothic' armour, a youthful nobleman wearing a tunic and coronet, and a gentleman or franklin – the lowest form of nobility – in a tunic and hat. Together they display the lesser nobility from knight down to men at arms in Medieval England. They may well have been displayed high on a wall in the great hall of the castle, as their backs are flat and their heads thrust forward, and they may have carried banners displaying the coat of arms of the Dacre Family who owned Naworth Castle in Cumbria. To be noble in fifteenth-century England was to be a warrior but these three smiling, benign-looking men do not look war-like. We need to pay attention to what they wear and carry in order to understand these figures. The youthful figure is probably a squire and certainly a good dresser in his mantle of mail, his small hat and his fur-trimmed skirt. He has a dagger but also carries a purse or knapsack, suggesting a degree of financial freedom which the others do not have.

'He was a verray parfit knight.'
– Geoffery Chaucer, *The Canterbury Tales*

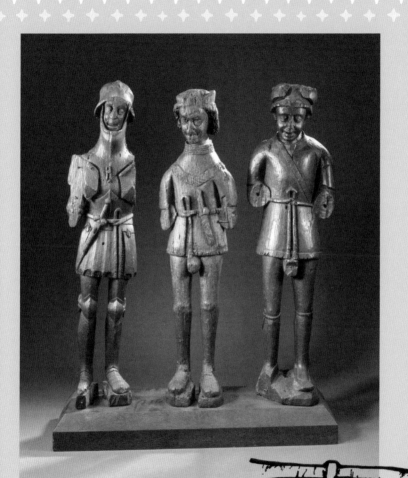

Key ingredient:

Purse or Knapsack on
the Youthful Nobleman

Key ingredient: Christ's Right Hand

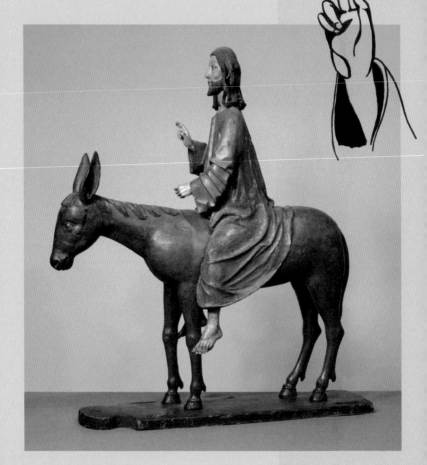

'Look, your King arrives!
He's coming to you full of gentleness,
sitting on a donkey,
riding on a donkey's colt.' – Matthew 21: 5

Christ sitting on an Ass c. 1480

Tasting notes

Imagine Christ with reins in His hand and the wheels on the base of this limewood and pine sculpture, probably from Ulm in Germany, and you will be able to reconstruct the traditional procession on Palm Sunday through the streets. These processions date back to the fourth century, although the use of sculptures is probably more tenth century in its origins. This sculpture, which would be towed, commemorates the humble Entrance into Jerusalem of Christ who sits on an unsaddled lowly ass, blessing the crowds with his right hand (with one finger joint missing). These sculptures were called *Palmesels* in Germany and this is one of few surviving examples, made around the same time, also used during Palm Sunday processions. Sculptures were usually painted and gilded. We can still see the paint on the body of the ass, its mane and tail, as well as the gilding on the border of Christ's robes and the polychromy on His head, hands and feet, suggesting that although He is humble, He has heavenly status.

The National Gallery

Trafalgar Square
London
WC2N 5DN
www.nationalgallery.org.uk

The National Gallery opened to the public on 10 May 1824 as a place for 'the enjoyment and education for all in central London'. Its location was strategically chosen so that the rich could approach the gallery by carriage from the west but was also within walking distance of the poor from the east. This national treasure has grown substantially from the thirty-eight pictures purchased from the banker, John Julius Angerstein for £57,000. A good map is required to find your way to the pieces we have chosen and don't hesitate to ask the helpful attendants for directions. Moving beyond the Middle Ages, Man rediscovered the Classical world and enjoyed the intellectual pursuits of Humanism, finding New Perspectives and literally changing the way they looked at the world.

The Arnolfini Portrait

ARE WE THERE, at the door or in the mirror to be greeted by Giovanni di Nicolao Arnolfini? Or perhaps the painter is reflected with a friend? His graffiti-like signature on the wall attests to his presence. As a member of a merchant family from Lucca but now living in Bruges, our merchant is polite in his greeting and presents his wife to us. The bed in the living room with its carved figure (possibly St Margaret, the patron saint of pregnancy), the oranges on the sill, the all-seeing convex mirror, the brass chandelier and the rosary beads all announce Arnolfini's wealth and status, as do the couple's clothes. She holds up her voluminous green skirt, and surely we marvel at the texture. Also that of the fur, silk, fine hairs on the dog, cherries on the tree outside, brass, plaited straw on his hat, the jewellery and the single candle as well as the cast aside clogs. The little lap dog looks out at you. A symbol of loyalty or lust, he could be a gift between them or a sign of their elevated status at court, perhaps a rare breed – a Brussels Griffon? Read all the signs and symbols and you realise that Van Eyck reconstructs an enigmatic world for you to decipher.

Key ingredient: **THE DOG**

'...*a reconstruction rather than a mere representation of the visible world.*' – JAN VAN EYCK

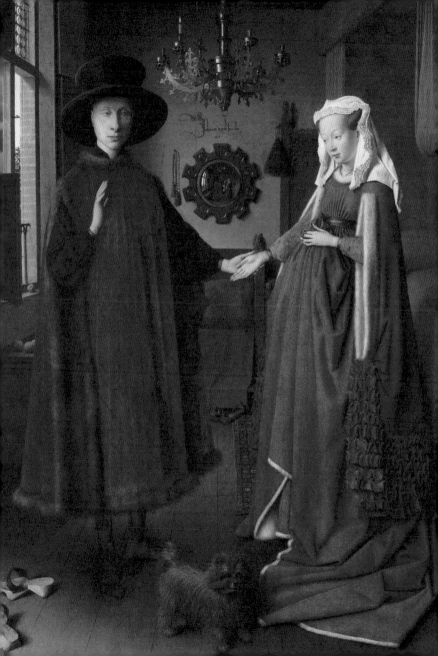

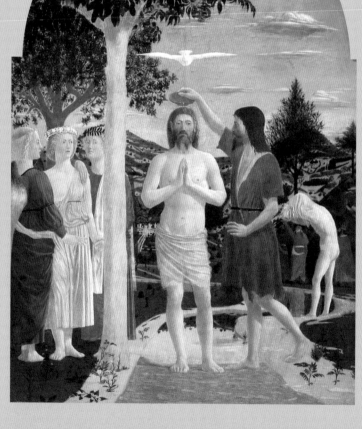

The Baptism of Christ

PIERO DELLA FRANCESCA, AFTER 1437

THIS CENTRAL PANEL of an altarpiece was commissioned for the small chapel of Saint John the Baptist in the (now) cathedral of Piero's native town of Borgo Sanseplocro in Tuscany, which you can just make out in the distant hills between Christ and the walnut tree to the left. This apparently simple composition belies a complex and perplexing painting well expressed through the quizzical look of the central garlanded angel on the left. Through her eyes we ask questions. Why does the water of the river, which was Jordan, stop at Christ's feet? Why did He ask John the Baptist, in his penitential robes, to perform a ceremony when He is the Son of God? This is clearly also, just one of the baptisms which was happening on that day, as someone else prepares to take off his shirt. Beyond that figure there are further figures who are dressed in what may be Eastern costumes. Do they represent a memory of the Magi? Or are they a reference to the liturgical calendar? Set in Tuscany, which even the presence of local plants makes clear, the painting suggests the omniscience of Christ and in a remarkably mathematical way expresses the miracle of this event.

Key ingredient
CENTRAL GARLANDED ANGEL

Venus and Mars

SANDRO BOTTICELLI, C. 1483

'Meanwhile the bard began to sing the loves of Mars and Venus, and how they first began their intrigue in the house of Vulcan.' – HOMER, *THE ODYSSEY*

Key ingredient: WASPS

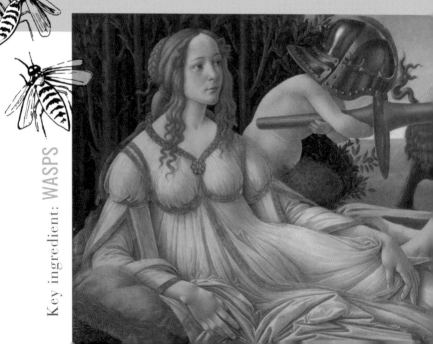

THE YOUTHFUL AND adulterous lovers lie in a wooded landscape full of myrtle and laurel, and possibly even some plants with more dangerous or noxious properties. She, Venus, the Goddess of Love, is fully clothed, regal in her gold-trimmed gown, calm, perhaps sated or possibly bored after their amorous activities; he is semi-naked and has fallen deeply asleep. So deeply, that the little satyrs cannot wake him while they play with his armour, nor can the wasps buzzing around his head, possibly a reference to the Vespucci family who owned several Botticellis. Mars, God of War, brother of Vulcan her husband, is unmanned, snoring and abandoned. We do not see the moment they are discovered and wrapped in a fine net by the cuckolded husband. Here we see them in very human, if not humorous poses, for gods. Her disinterested gaze is not for her snoring lover, his mouth is open, his legs crossed and the cloth about to fall. A timeless painting about love and marriage; mythological yet relevant still today.

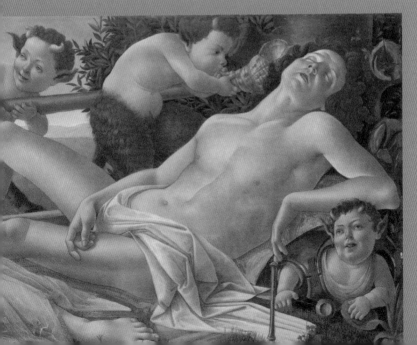

COMMISSIONED IN 1483 and finally delivered to the Confraternity of the Immaculate Conception as an altarpiece for their church, San Francesco in Milan in 1508, Leonardo, angry with the sum of money he was offered, sold the first work to a private client and it is now in The Louvre, Paris. This is the second version which he eventually agreed to do. Probably done over the top of another painting of a kneeling Virgin, here we see the young and gentle Virgin Mary in blue and orange robes, her right arm protectively cradling Saint John (The Baptist) and her left hand hovering over Christ who is guarded by an angel. They all seem to be appearing out of an extraordinarily detailed geological landscape, blending in, as if they were hewn into the rocks. According to legends and non-biblical sources, the group are taking cover while fleeing from The Massacre of the Innocents and this is possibly the moment when the two young cousins meet. There is water behind them but it is the still water in front of them which foreshadows the later event when Saint John will baptise Christ.

Key ingredient
THE WATER

The Virgin
of the Rocks

LEONARDO DA VINCI, 1491/92 AND 1506–8

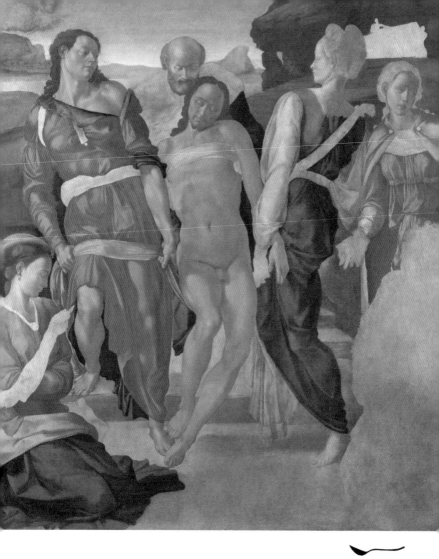

'Death and love are the two wings that bear the good man to heaven.' – MICHELANGELO

THE ENTOMBMENT
Michelangelo, 1500–01

Tasting notes

AN UNFINISHED PAINTING attributed to Michelangelo affords us a rare opportunity to see his under-drawing and how he planned the composition of his works. The work was commissioned for the church of Sant'Agostino in Rome but when Michelangelo got a better offer, he gave back the money he had received. In the centre of the panel, Christ, having been crucified, is being hauled up some steps to the sepulchre. The other figures are disputed. Behind him is probably Joseph of Arimathea. On the left is likely to be Saint John wearing a long orange-red gown and supporting the body with linen bands. Mary Magdalene is probably at his feet, contemplating something in her hand – maybe the crown of thorns. However, the other two figures are even more uncertain. Perhaps Nicodemus is on his immediate right, although the figure does seem very feminine in stance, and Mary Salomé on the far right. The Virgin Mary was to be placed in the foreground, a fact which is ironically less disputed, as we can see in the preparatory study in the Louvre. The drawing of the body of Christ is exquisite in its execution. Lifeless and heavy, its weight borne by others around, it has been washed, thorns and nails removed, and all signs of blood have vanished.

Key ingredient: **THE BODY OF CHRIST**

THE MADONNA OF THE PINKS

RAPHAEL, 1506–07

YOU MIGHT LIKE to imagine holding this little painting in your hand and meditating, praying or just thinking as you touch and sense its presence. The young Virgin Mary sits in a bedchamber and has perhaps cast aside the curtain surrounding the bed so that the light from the window on this lovely sunny day can shine on a tender moment between mother and son. In the distance we can see what looks like a ruined building, which may symbolise the collapse of the pagan world and the birth of Christianity. Mother and child are handing each other carnations (pinks). The botanical name of this flower means 'Flower of God' and they may foretell the Passion of Christ, as according to Christian Legend they are mentioned when Mary, mother of Jesus and Bride of Christ, witnessed carnations growing out from where her tears fell, as she watched Christ carry the cross. This work suggests that as Mary loved her child, so did He love her, as He either gives or receives the gift. This painting was denounced as a copy in 1860 but by 1991, under closer scrutiny it was declared a Raphael and it was bought by The National Gallery in 2004.

Key ingredient
THE CARNATIONS

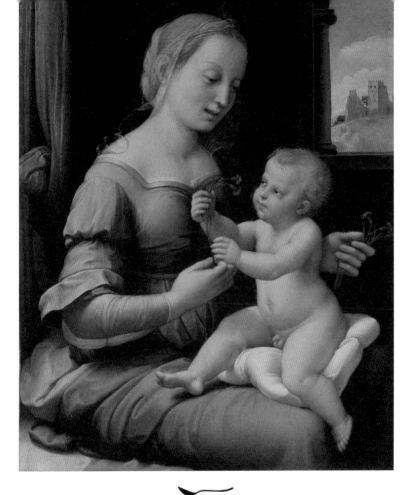

'Not yet on summer's death nor on the birth
Of trembling winter,
the fairest flowers o' th' season
Are our carnations.'
– SHAKESPEARE

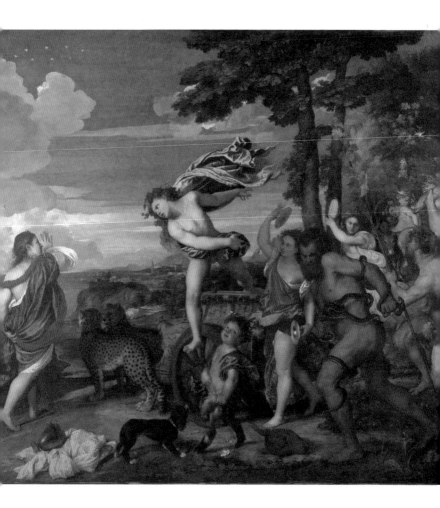

'Bacchus-Liber brought her help and comfort.
So that she might shine among the eternal
stars, he took the crown from her forehead,
and set it in the sky.' – OVID, METAMORPHOSES

Bacchus and Ariadne

TITIAN, 1520–23

Tasting notes

ARIADNE, DAUGHTER OF King Minos, abandoned by Theseus on the Greek island of Naxos, still points desperately towards his ship on the horizon but we witness the first moment when she spies the god Bacchus and although initially fearful, falls in love. Her body twists towards him as he leaps from his chariot, travelling from India with drunken revellers, and accelerates towards her into an extraordinary and unlikely leap. His pink attire is whisked away from him as his eyes lock with hers. His unruly band of followers features a Laocoön-like figure with snakes, a satyr dragging a head and Silenus already in a drunken stupor. How can Bacchus, a god, ever keep a mortal? He finds a way and takes the crown off her head and changes her into a constellation of eight stars which we see in the sky above her head. The *Corona Borealis*. We are overwhelmed by the visual impact of this work; a frieze-like composition which seems to whip across the surface from right to left, mirroring the movement of the brushstrokes. Only the cheetahs who were drawing the chariot stand still and take us into the landscape beyond.

Key ingredient:
THE CONSTELLATION OF STARS

The
Ambassadors

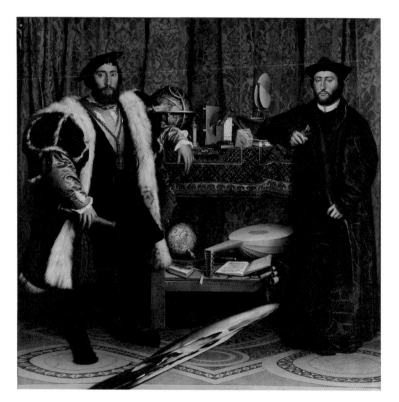

'Remember thou shalt die.'
– JEAN DE DINTEVILLE'S MOTTO

JEAN DE DINTEVILLE (left) and Georges de Selve met up in London in April 1533. Jean was an erudite, trusted Ambassador from the French court of Francis I, who owned a chateau which he wanted to return to. Here he is seen sumptuously dressed in fashionable lynx fur, holding a gold dagger which bears his age (twenty-nine). Trapped in London by Henry VIII's marriage to Anne Boleyn, he was delighted his friend Georges, also an Ambassador to France and Bishop of Lavaur, visited briefly during that tumultuous year which saw the split between the Lutheran and Catholic church. We note Holbein painted the two men wedged between a silver cross on the top left of the painting and – an extraordinary feat of painting – an anamorphic skull at the bottom, balanced on what looks like the Cosmati pavement in Westminster Abbey. If you stand to the right, the skull will gradually reveal itself to you. We note the oriental carpet, the instruments of time on the top shelf, including a celestial globe and on the bottom shelf a terrestrial globe and the instrument of discord, the lute with a broken string. These two men were there to provide religious and political harmony during a discordant time; an almost impossible task.

Key ingredient
THE ANAMORPHIC SKULL

IF YOU SAT down at the available chair in the front of the table, the basket of fruit, balanced precariously on the edge of the table might fall into your lap. You would, however, witness an astonishing moment, when two unsuspecting disciples who, travelling on the road, had quite simply invited a weary traveller to join their meal, only to discover that He is the risen Christ. The innkeeper witnesses, as you do, a revelatory moment. On the right, Cleopas, red-nosed with cold and wearing the scallop shell of a pilgrim, gestures expansively. Caravaggio depicts him as amazed that Christ sits with them, blessing their bread. On the left, Luke, in his torn green jacket, is stunned and frightened, and pulls back his chair as if he cannot quite bear to believe it. Christ, unbearded, some say feminine, looks down at the food which they will share. This is pure theatre. The shallow stage with its bright lighting and shadows on the wall is set for high drama. The figures draw us in because they are life-size and ordinary, the food inviting, but the world they live in is as precarious as the fruit bowl at this moment after the crucifixion.

Key ingredient
THE BASKET OF FRUIT

THE SUPPER AT EMMAUS

CARAVAGGIO, 1601

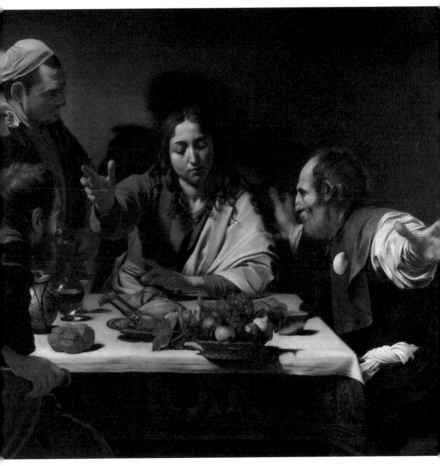

'And their eyes were opened, and they knew him; and he vanished out of their sight.' – LUKE 24:31

THE ROKEBY VENUS

DIEGO VELÁZQUEZ, 1647–51

'I would rather be the first painter
of common things than second
in higher art.' – VELÁZQUEZ

Tasting notes

WE ARE LOOKING very closely at the back view of a naked woman. She lies on a bed, her body following the curves of the grey sheets, one foot tucked under her leg and she rests on her arm as she appears to be staring into a mirror. The artist Velázquez knew of the existence of the Arnolfini Double Portrait (see earlier pages) as it was in the Royal Alcazar in Madrid at the time of painting. We follow the line of her splendid back up to her lightly flushed face and down her spine to the reflection of a blurred face in the mirror, which barely resembles what we can see of her own. The mirror is held up by a little boy with wings who is clearly Cupid and here lies the key. If he is indeed Cupid, then she must be Venus but portrayed as never seen before from the back. Our powerful imaginations allow us to see her front and make out her face and her body in front of a fabulous red silk curtain. The loose brushstrokes are visible everywhere except on the body and we are left marvelling at the technique of this painting. Owned by the Duchess of Alba, then Godoy, her minister, and later John Morrit who hung it in Rokeby Hall in Yorkshire, it came to the National Gallery in 1906. It was attacked by the suffragette Mary Richardson in 1914 but fortunately was beautifully restored.

Key ingredient
THE WINGS

Designed by Sir John Soane as the first purpose-built public art gallery, Dulwich Picture Gallery opened to the public in 1817. Art dealers, Noël Desenfans and Sir Francis Bourgeois, had been commissioned by Stanislaus Augustus, King of Poland to buy a royal collection. When he was forced to abdicate, the art dealers were left with the stock they had amassed, much of which became the property you will see within these walls. In this gallery you will encounter a flamboyant, colourful Theatrical World with strong contrasts of light and darkness, and moments of high drama in the figures and the landscapes.

4. DULWICH PICTURE GALLERY

A Theatrical World

Gallery Road
London
SE21 7AD
www.dulwichpicturegallery.org.uk

SAMSON AND DELILAH

ANTHONY VAN DYCK, C. 1618-20

'If my head were shaved, my strength would leave me, and I would become as weak as any other man.' – SAMSON, BOOK OF JUDGES 16:17

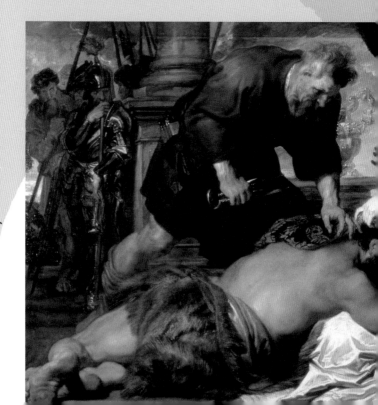

The great and powerful Nazarite, Samson lies asleep and vulnerable in the lap of the woman he loves. His extraordinary trust and lust are highlighted by the way his muscular body seems abandoned and intertwined with hers and yet his dirty feet visible. The light shines on the untrustworthy Delilah who has sold him to the Philistines, her own people, for 1,100 silver coins. She has found out, through much sexual wiliness, that his strength lies in his hair and Van Dyck, a pupil and assistant of Rubens at this time, has chosen to depict the moment before Samson is captured. The tense moment when a Philistine approaches Samson with shears rather than simple scissors, looking intently at his hair which we know he will cut. Delilah lies in fine silver garments, perhaps suggesting the coins; one pale hand rests on her milky breast half covering it but also lifting a warning finger for us all to be quiet and the deed to be done. Those present seem in awe, including the procuress behind Delilah. We too hold our breath, wanting him to awaken and defend himself but his fate is sealed.

KEY
INGREDIENT:
The Warning
Finger

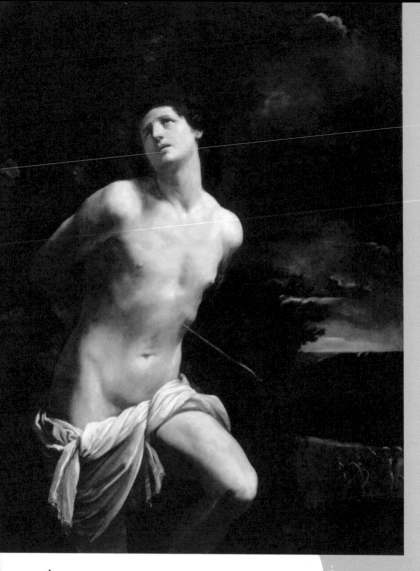

'And the archers shot at him till he was as full of arrows as an urchin is full of pricks, and thus left him there for dead.' – THE GOLDEN LEGEND

SAINT SEBASTIAN

Guido Reni, c. 1630-35

Tasting Notes

Sebastian was a Roman soldier, condemned to death in AD 286 by Emperor Diocletian for aiding the Christians and hiding his own faith. Normally tied to a tree or a column for the three arrows – possibly representing the Trinity – to be shot at him, he is seen here in an uncertain space with just a hint of a landscape in the distance. His taut body seems to flex in pain as one arrow has pierced his side but at that moment he looks up towards heaven as if certain that this is where he will ascend. The obvious pain of the arrow is somehow alleviated by his trust in God. His nakedness is broken by a loin cloth which barely covers him, highlighting his pelvic bone, his ribs and his shoulders, taking our eyes up to his gentle face in the half-light between life and death. Yet we know he will not die at that moment. He will be nursed back to health by Irene of Rome and will only later be clubbed to death by the soldiers of Diocletian after he has dared to harangue the Emperor for his treatment of Christians. This painting has been damaged around the edges, but cleaning has revealed masterful brushstrokes of great virtuosity.

Key Ingredient:
The Arrow

THE TRIUMPH OF DAVID

NICOLAS POUSSIN, C. 1631-3

TASTING NOTES

Poussin's extraordinary theatrical masterpiece gives clarity to the story of David's return to Jerusalem after having slain the giant Goliath with a sling and stone.

David, in red, has Goliath's extraordinary head on a spike and we see the wound of the rock still visible on the giant's forehead, reminding us of the story. The eyes are shut but the mouth is open. The profile of both the face of Goliath and that of David accentuates the considerable size of the giant. The colourful spectators, who had been going about their daily business in and around the temple, respond to the arrival of David, and two musicians herald his heroism and triumphal entry. We situate ourselves amongst a cross-section of humanity, old and young. We see all of the figures so clearly because of the different levels and colours which highlight everyone's responses. Some give thanks, some stand in awe, some gossip amongst themselves, others point or open their arms and the small children in the foreground barely seem to notice as they continue to play.

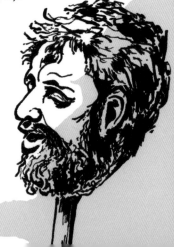

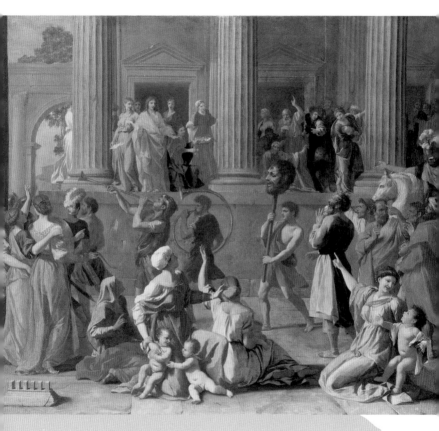

'David took the Philistine's head
and brought it to Jerusalem...' – 1 SAMUEL 17:54

KEY INGREDIENT:
The Head of Goliath

VENUS, MARS AND CUPID

Sir Peter Paul Rubens, c. 1635

Like Rubens' earlier painting called *Peace and War* (1629–30), painted when he was sent as a diplomatic envoy by Philip IV of Spain to try and negotiate peace between England and Spain, the theme of this painting seems to be the triumph of love over war. Mars, God of War, looking tenderly at the scene of Venus breast-feeding their child, Cupid, has laid down his helmet and shiny shield with a monstrous face carved on it, in a deliberate act of disarmament to suggest that this peaceful scene matters more than war. Cupid's arrows are on the ground and he appears to be clambering up on to his mother's lap as she shoots her milk into his mouth (and eyes), reminding us of scenes of the Virgin Mary lactating. Cupid looks as if he might fall into the helmet's terrible face but is saved. The couple gaze down on the fruit of their love; he, still wearing his body armour, is silhouetted by a luscious red curtain with putti playing behind his head and her velvety blue cloth hides part of her mostly naked, fleshy, sensual body. This painting was eventually given to Charles I.

Key Ingredient:
Mars' Shield

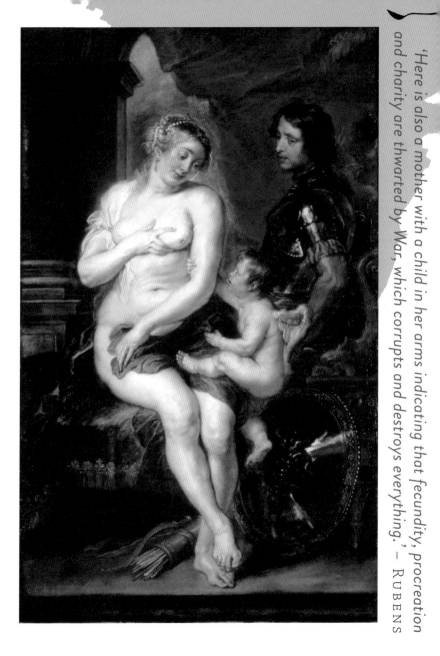

'Here is also a mother with a child in her arms indicating that fecundity, procreation and charity are thwarted by War, which corrupts and destroys everything.' – RUBENS

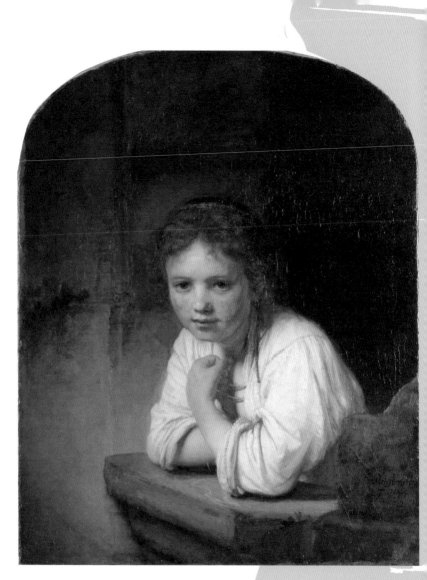

'Without atmosphere a painting is nothing.' – REMBRANDT

GIRL AT A WINDOW

REMBRANDT, 1645

TASTING NOTES

According to legend, Rembrandt placed this painting by a window in Amsterdam and at first, passers-by thought it was a real serving girl leaning on a ledge and looking out. The ledge formed the link between the inside and the outside of the house. Whether that is true or not, her warm flesh and keen gaze are life-like enough for us to believe this and stare at her as if she really is at the window and we can chat to her. The thickness of paint laid on coarsely with brushes, a palette knife and fingers forms a layer which suggests linen, stone and flesh. The painting gives us the illusion of reality as the girl peeps into our space, yet the light around her creates a sense of the supernatural, almost as if the light is, in fact, body heat. She is young, but her gaze is worldly; an astonishing feat in paint. We too feel like the people of Amsterdam, that we could reach out and touch this figure as she is so life-like and warm.

KEY INGREDIENT:
The Window Ledge

LANDSCAPE WITH WINDMILLS NEAR HAARLEM

Jacob van Ruisdael, mid 1650s

Tasting Notes

We are on this road in Holland, we feel the bleakness of this landscape and the cold blustery day, where the sun might peek through thick clouds – very rarely but enough to send shafts of light across the landscape. The scene feels like a real experience, which is why John Constable copied the painting in 1831. Do compare the paintings, often both on display. The reason why it feels so real is because we have a single viewpoint and our eyes are low because the landscape is so flat. At first glance, the subject is banal. A silage mound obscures much of the city of Haarlem, but we can make out one of the main churches, the Groote Kirk, a ditch, a shack, dunghills and two windmills. When it was owned in the eighteenth century, a couple of extra figures were added below the further windmill but these, although copied by Constable, were later removed in 1997. To complete the sense of bleakness we see a woman in red at the door of her hovel where she has lit a fire, giving alms to a poor boy.

KEY INGREDIENT: The Woman

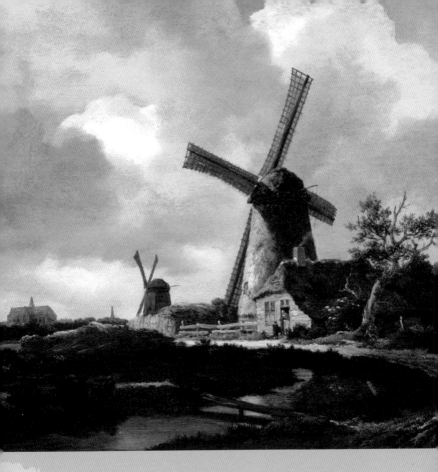

'Dutch painting ... was and could only be a
portrait of Holland, its exterior image, faithful,
exact, complete and without embellishment'
– EUGÈNE FROMENTIN

A ROAD NEAR A RIVER

AELBERT CUYP, C. 1660

KEY INGREDIENT:
Distant Mountains

TASTING NOTES

Moving away from his normally low viewpoints, we can see this is a late painting by Cuyp. Although we are on the road, it slopes up towards the left where one travelling figure points and the tall trees dominate the scene. We are beside a river or canal where some people, possibly shepherds, have stopped to rest and let their sheep graze or sleep. The sheepdog seems peaceful too, so all is calm in this sunset scene. Instead of the insistence on the real that we have experienced in Ruisdael, Cuyp is more poetic in his approach to landscape in this painting. The fine foliage against a pale blue sky casts shadows, as do the people standing by the stream casting their reflections in the water. Above all, the distant mountains add drama and theatricality to the scene, as they would not be found in Holland, and the clouds form abstract patterns in the sky. Perhaps Cuyp wants to remind us that painting is after all theatrical artifice.

THREE BOYS

BARTOLOMÉ ESTEBAN MURILLO, C. 1670

TASTING NOTES

Seventeenth-century Seville, and three young children engage in a conversation. In the nineteenth century this painting was called *The Poor Black Boy* but we now see that the two white boys are probably poorer than the black servant boy who seems to be asking the others to share the pie. The young black boy's earthenware jug, his clothes and above all his shoes, tell us that he is not begging for charity. The white boy on the right is determined not to share what he has probably stolen anyway, and the other boy turns to us with a grin. They were, in fact, probably modelled by Murillo's sons, Gabriel and Gaspar, and the black boy could have been a portrait of the son of Murillo's servant girl Juana de Santiago, who Murillo freed in 1676. We would see under X-ray that the child on the left was originally shown with a much more aggressive look on his face as he groped in the standing boy's pocket. We now see him move to pull the black boy's hand away from the pie. This is an image of poverty which is probably not realistic of the time but allows Murillo to explore the plight of children.

KEY INGREDIENT:
The Pie

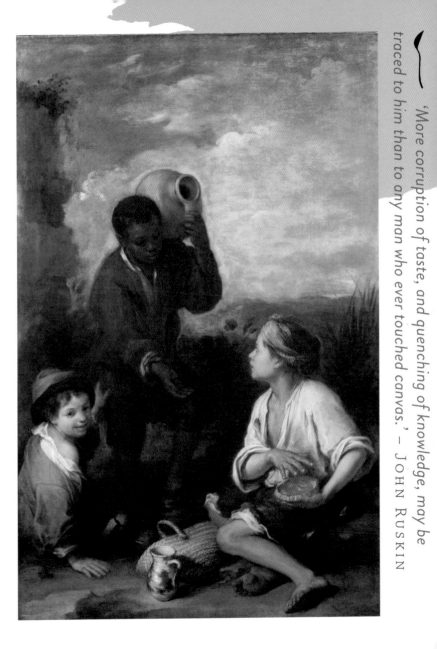

'More corruption of taste, and quenching of knowledge, may be traced to him than to any man who ever touched canvas.' – JOHN RUSKIN

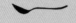

'Underlying the subject itself, whatever its precise meaning, is a display of dazzling skill and, ultimately, a celebration of art making.' – MARTHA HOLLANDER

A WOMAN PLAYING A CLAVICHORD

GERRIT DOU, C. 1665

She welcomes us with her glance, or does she bid farewell to someone who has been with her, making music on the viola da gamba or the flute, or sharing her wine glass? We do not know of course whether it is her glass or someone else's. Sunlight enters from the left. Dou's 'dazzling skill' lies in his depictions of light on objects such as the fabric of her dress, the sumptuous curtain, the floorboards and the wine cooler on the floor. In the middle of the room is the vital clue. The dangling closed bird cage suggests virginity, which may well have been taken by the owner of the glass. We feel like we have just pulled back the curtain and entered an intimate space and her gaze is understandably cautious. Here we have atmosphere created by sound and colour; the gentle tone of the clavichord and the memories of the other instruments. We might be invited to sit a while on the velvet cushion, or not!

KEY INGREDIENT:
The Bird Cage

CLAUDE LORRAIN, 1676

While tending Laban's sheep, Jacob, in red with outstretched hands, fell in love with the older man's younger daughter, Rachel. In lieu of wages he asked Laban if he could marry her but was told he would have to work another seven years. This he did, but was duped by being given, as was the custom, the older daughter, Leah, on the marriage day. When he confronted Laban, he was told he would have to work another seven years to gain the hand of Rachel. In the painting, evening has fallen as discussions take place. The landscape evokes the archaic world of the Old Testament and a familiar story, but Claude's genius lies in his ability to suggest that nature is much greater than human stories. Here we have the peacefulness and grandeur of nature with soft lighting and a sense of overwhelming calm. The scene has a poetic quality which both diminishes and highlights the story of labouring for love. The lighting is as tender as the story, yet we are distanced and can only imagine the pain of waiting.

KEY INGREDIENT:
Jacob

JACOB WITH LABAN AND HIS DAUGHTERS

'Because you are my kinsman, should you therefore serve me for nothing? Tell me, what shall your wages be?' – GENESIS 29:15

5

The Wallace Collection

Hertford House
Manchester Square • London • W1U 3BN
www.wallacecollection.org

Step into the Enlightened World of Hertford House. We enter the Age of Reason, where artists explored ideas and intellectual writers. You will see a sumptuous and decorative collection which is a feast for your eyes. You will be surprised and delighted by the collection, amassed by the first four Marquesses and Richard Wallace, the illegitimate son of the 4th Marquess. Lady Wallace, Richard's widow, bequeathed the house and art collection to the nation with the condition that no object should leave the collection, even on loan for exhibitions. Your search for the objects of art will be somewhat of a treasure hunt, as the art is displayed as it would have been in a eighteenth-century home.

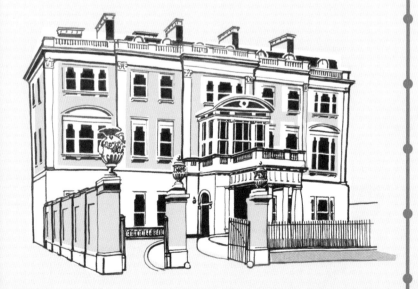

Voulez-vous triompher des Belles?

Tasting Notes

What you see is an idealised bucolic outdoor scene with a touch of theatricality. Search for Harlequin and you will find the key to this painting. In his chequered costume and black mask, he is nimble and wily as he reaches for his mistress Columbine, his counterpart from the Italian Commedia dell'arte. This foreground scene is contrasted with the characters in the background; a lutist and a woman holding a musical score are planning entertainment. They may all be actors either on or off stage. They imply and contrast social interaction, but also social masquerade at a time in France when the Italian Theatre had been banned yet French theatre continued many of its traditions. Influenced by Rubens, Watteau used oil colour with sweeping strokes, almost suggesting the fluid quality of relationships but who can we trust? 'Do you want to succeed with women?' Watteau asks his audience, either by engaging them in serious musical pursuits or by grabbing your moment like Harlequin. As someone who had no history of adventures of his own, one cannot but wonder if Watteau is suggesting the latter?

Key Ingredient: Harlequin

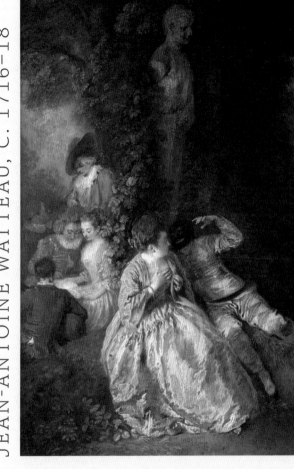

'I create the painting in my mind, colour gives me inspiration, passion is very important, so I am looking for radiance, with all my soul.'
— ANTOINE WATTEAU

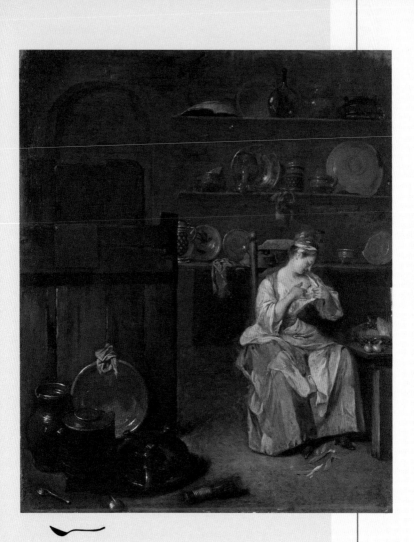

'But was there ever dog that
praised his fleas?' — W.B. YEATS

A Young Woman in a Kitchen

NICOLAS LANCRET, C.1720–25

Tasting Notes

The subtitle of this tiny painting on oak panel gives us the clue 'La chercheuse de puce' – 'the seeker out of fleas'. A young woman is inspecting herself for fleas, in the corner of a room where she sits alone; an activity which was relatively normal amongst the poorer classes in eighteenth-century France. Yet we are told that this painting was painted over an existing painting of a gloomy Dutch kitchen with an empty chair and a dog. Lancret has added a more typical French flavour, showing her bare breast, perhaps to titillate, semi-laced corset and silk skirt. We are in an intimate space and surely not meant to be there. She sits amongst the pots and pans, with a delicate still life on the table. Her striped dress echoes the colours of the pans, yet brings the painting alive in its array of colours. Perhaps she was preparing food when she stopped to check? It seems extraordinary now that the painting has survived as an amalgam of two artists, yet it was common practice in those days to paint over existing paintings and this is an excellent example. Lancret's additions have certainly enlivened the work and given it some erotic appeal.

Key Ingredient:
Her Striped Dress

The Riva degli Schiavoni

CANALETTO, 1740–45

'This was Venice, the flattering and suspect beauty
– this city, half fairy tale and half tourist trap…'
— THOMAS MANN

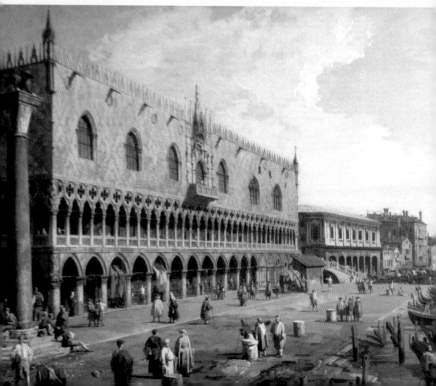

You walk into this painting, following the sweep of the Grand Canal, almost as if you have just got off a vaporetto (boat) in Venice today. Nothing seems to have changed and you join the people on the vast promenade walking past the columns of San Todaro and the Lion of St Mark. You see on your left, the Doge's Palace in all its splendour; a reminder of Venice's colourful history. You stand on the Piazzetta for a moment and breathe in the atmosphere which this Venetian artist creates in every painting around you in the galleries. Perhaps you will take a trip on one of the gondolas on your right, which seem to be happily bobbing up and down on the slightly choppy water, their gondoliers handling them with consummate ease. If you investigate the distance, you can see one of the many bridges, the Ponte della Paglia and the prison beyond. This is a busy city and a tourist attraction then and today. Although Canaletto had worked on stage sets for Vivaldi and Scarlatti operas, these works sold well particularly amongst the English tourists and were sent 'back home' as reminders of the wonderful time they had spent in this most attractive city.

Key Ingredient:
The Doge's Palace

Santa Maria della Salute and the Dogana

Key Ingredient:

The Domes of Santa Maria della Salute

You have experienced Canaletto, now you move to Guardi and while still enjoying the views of Venice you feel, perhaps, that the mood has changed. Topographical accuracy has given way to a poetic, softened, seductive and moody vision of the city. A reminder, perhaps, that despite its obvious beauty, what lies beneath crumbling palaces is a decadent, claustrophobic city on the wane. We look across the Grand Canal now towards the domes of the most important Baroque church in Venice, Santa Maria della Salute. Guardi has widened the mouth of the canal in order to give us a larger stage to set this church against a cloudy blue-silver sky which is echoed in the colours of the shiny domes which dominate our view. We are on the water and seem to be approaching the church with all the awe-inspiring spiritual wonderment we can muster. This is not the self-important city of Canaletto but a wistful elegy; the precursor to Turner, Ruskin and the Impressionists.

Tasting Notes

'In Venice...
Silent rows the songless gondolier;
Her palaces are crumbling to the shore,
And music meets not always now the ear.'
— LORD BYRON

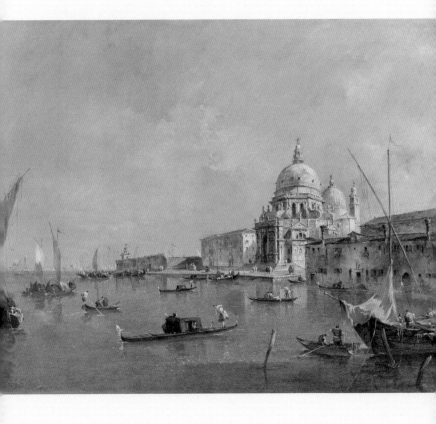

– Madame de Pompadour –

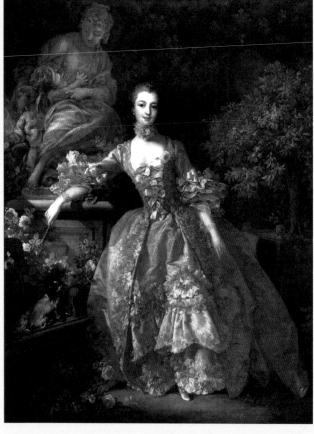

FRANÇOIS BOUCHER, 1759

} *'Madame de Pompadour excelled at an art which the majority of human beings thoroughly despise because it is unprofitable and ephemeral: the art of living.'* — NANCY MITFORD

Here she is, one of the most famous mistresses of all time. Madame de Pompadour, mistress of the great Louis XV wielded financial and political power due to her wit, charm and education. Beautiful pink brushstrokes swirl across the canvas, outlining the fashion of the time and further highlighting her elegance and beauty. A fortune-teller told her mother that she would one day have the heart of the king, so she was groomed for this position which she took on in 1745. She held court to some of the great men of the Enlightenment, such as Voltaire, and became invaluable to the king; so much so that when their sexual liaison ended she took on an official position as 'friend to the King' and would remain in this important role until her death at forty-two. As Boucher's patron, she commissioned this work herself and stands leaning gently on the base of a sculpture by Pigalle of *Friendship Consoling Love*, in the presence of her pet spaniel Inès, who further stresses the notion of fidelity. This work is one of a series where she is portrayed in her two roles of friend and faithful one.

Key Ingredient:
The Spaniel

'...*the painter of virtue, the rescuer of corrupted morality.*' — DIDEROT

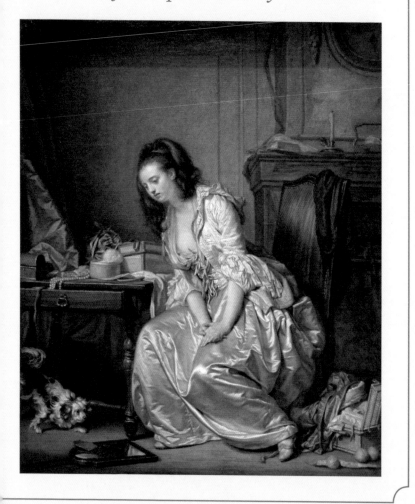

The Broken Mirror

Tasting Notes

With her dishevelled attire, her hair loose and her red cheeks, this young woman is surely down on her luck. However, there are more hints in this painting which further the connection between disarray and morality. Her ringless fingers clasped anxiously, she stares down beyond her broken mirror on the floor. We wonder if she broke it wittingly or if it fell from the overburdened table. The dog has backed off slightly and is perhaps yapping anxiously too. We are witnessing a sad scene. We cannot fit in this unwelcome room and nor would we want to enter. There is no space for us, just as there is barely space for her. Her dress, shoes and pearls suggest better times but more recently she has experienced a loss; her virginity, her suitor, her family or all three? Interestingly, the fabric of her dress is like the curtains. We can speculate that it is made from them. This is a genre scene and a parable of carelessness. The pearls spill over into the drawer and we wonder if they are broken, denoting further bad luck.
Perhaps she is desperate.

Key Ingredient:
The Pearls

The Swing

Key Ingredient:
The Shoe

Tasting Notes

The original title, *The Happy Accidents of the Swing*, offers us clues. The commission was originally given to the history painter Gabriel François Doyen by an unnamed gentleman who wanted his mistress painted on a swing with a bishop pushing her while he, the gentleman, was admiring her legs. Doyen refused the commission but suggested Fragonard paint this erotically charged work. An older layman pushes a beautiful girl while a young man half-hidden in the bushes, looks right into and up her skirts. The sharp diagonal emphasised by his arm and the ropes makes explicit what he sees. Look out for the barking dog, the sculpture which was called *Menacing Love* and the little Cupid who puts his finger to his lips in a warning gesture to us while he watches the event. Note too, the stone sculptured cherubs at the side as one looks away and the other looks on in dread, as if this kind of voyeurism goes well beyond the world of warm flesh. But above all look carefully and you will see that the sign of her ultimate abandon is her pink shoe which she flips gaily into the air.

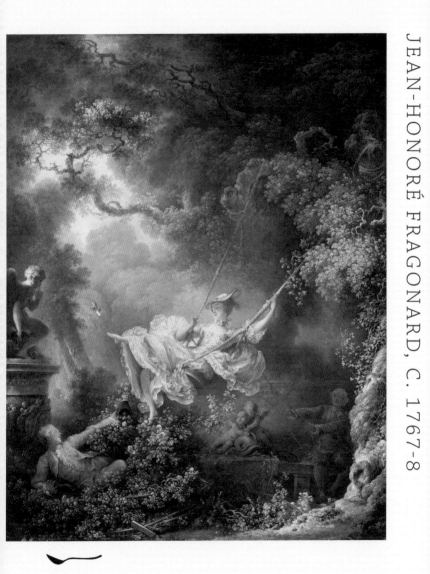

JEAN-HONORÉ FRAGONARD, C. 1767-8

'Have a little more self-respect.' — DIDEROT

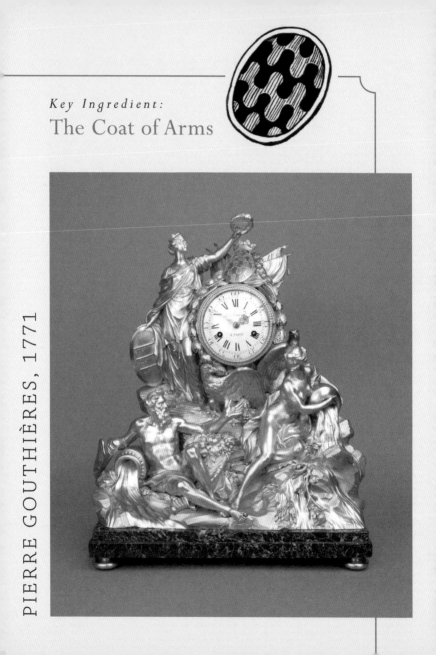

PIERRE GOUTHIÈRES, 1771

The Avignon Clock

Made of gilt bronze, Rosso Levanto marble, brass, glass and enamel, this clock, considered one of the great masterpieces of the Parisian bronze-maker Pierre Gouthière, is a sculptural piece of great beauty and a stark reminder of the opulence which preceded the French Revolution. The terracotta model was made by Louis-Simon Boizot but Gouthières supervised the moulds and the assembling, the chasing and the gilding; enough work certainly to warrant his own signature on the back of the clock. The clock was presented by the city of Avignon to the Marquis of Rochechouart and included his coat of arms. Under the command of Louis XV, the marquis had taken possession of the city which had been under papal jurisdiction since the Middle Ages. As a gift of thanks, Ange Aubert, a Parisian jeweller delivered it to him in 1772. The case is formed as a rocky hill and two figures recline at the base of it symbolising the rivers Rhone and Durrance which flow through the city. Jupiter's eagles support the clock and fittingly symbolise power and strength. The Classical female figure to the left of the dial represents Avignon and crowns the Marquis's coat of arms with a wreath of oak leaves. The movement of the clock itself is sophisticated and evokes the beating heart of the city.

'Clocks were invented to warn us.' — KAMAND KOJOURI

Mrs Mary Robinson: Perdita

This painting, presented to the 2nd Marquis of Hertford in 1818, had been withdrawn by the artist from the Royal Academy exhibition of 1782 due to criticisms that it did not show sufficient likeness to the sitter Mary Robinson, who was a well-known actress, writer, and poet, as well as much painted and caricatured at the time. Her famous role in Shakespeare's *A Winter's Tale* had earned her the ironic nickname Perdita (lost). Her seductive performance attracted the attention of the Prince of Wales, who later became King George IV. She had a brief affair with him and when he ended it, she sought a financial settlement by blackmail. He paid her, so the story goes. In the painting she melts poetically into the landscape around her and, with hooded eyes, stares wistfully and seriously out at you, accompanied by her faithful dog and, in her hand, a small miniature of the future king – a gift to her from him during their liaison and a reminder perhaps of their closeness at one moment and her subsequent disappointment.

Key Ingredient:
The Miniature Portrait

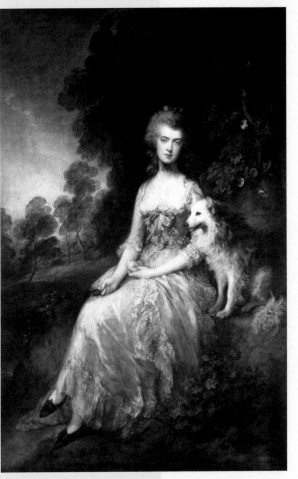

THOMAS GAINSBOROUGH, 1781

Her hair, dishevel'd, wildly plays
With every freezing gale;
While down her cold cheek, deadly pale,
The tear of pensive sorrow strays;
— MARY ROBINSON

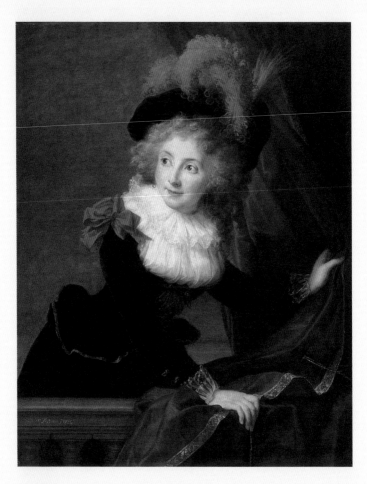

'The passion for painting was innate in me. This passion has never failed, perhaps because it has always increased with time; even today, I experience all its charm, and I hope that this divine passion ends only with my life.' — ELISABETH VIGÉE LE BRUN

Madame Perregaux

1789

Tasting Notes

This is one of the last portraits Elisabeth Vigée Le Brun painted before she fled from France on the eve of the French Revolution, only to return at the end of her life. Married to the art dealer and banker, Le Brun he sent this work to the salon of 1791. The sitter, Adélaïde de Praël, married Jean François Perregaux, who was banker to the Le Bruns, ten years before this flattering portrait was done. Le Brun collected art and advised her husband. Emulating Rubens, the work is done in oil on panel, a slow and laborious process allowing for fine brushstrokes which we see on the glorious red feather and the fine hair. This young woman seems to peek out from behind the curtain to reveal a three-quarter length natural beauty. The costume is extravagant with its jaunty hat and large feather, ruffles on the neck and sleeves, and the bright red details against the black velvet. Seen as Spanish at the time, it is both rakish and elegant, artificial and natural, glamorous and energetic. She looks beyond us from her balcony and yet we enter her space, briefly tempted to call out to her. Is she indeed part of a dying Ancien Régime?

Key Ingredient:
The Feather

Tate Britain

Escaping an Industrial World

Sir Henry Tate, the sugar merchant, offered his collection of sixty-five British nineteenth-century paintings to the National Gallery. They rejected his offer due to lack of space, so Tate founded a new gallery with a personal donation of £80,000. It was built on Millbank, the site of the former Millbank Prison, and opened its doors on 21 July 1897 as The National Gallery of British Art. It was later renamed the Tate Gallery in 1932 and when Tate Modern opened in 2000 it was renamed once again as Tate Britain, housing works of contemporary and historical British art. In a world which heralded new manufacturing processes, you will see that artists frequently *Escaped the Industrial World* into theatrical and literary subjects, sometimes overwhelmed by the sublime beauty of nature.

Millbank
London
SW1P 4RG
www.tate.org.uk

The Beggar's Opera

William Hogarth, 1731

A beautifully crafted stage setting lends perfect balance to the composition and subject matter of this satirical piece. Note the touches of red on both sides and in the middle, and the perfect perspective of the jail in the background. *The Beggar's Opera* by John Gay provided the English eighteenth-century audiences with a new way of experiencing musical entertainment. Satirising the grand opera in the Italian tradition, Hogarth gives us real people instead of gods, choosing to depict the moment when Macheath, under sentence of death, has two women pleading for his life. Both Lucy Locket and Polly Peachum believe they are married to him. First put on by John Rich at Lincoln's Inn Fields Theatre in London, the show was a huge success and had a long run during which the Duke of Bolton, seated on the right and wearing the sash and star of the Order of the Garter, fell in love with the leading actress. Lavinia Fenton, dressed ironically in white and playing the part of Polly Peachum, was renowned for her beauty despite her own lowly background. She not only caught the duke's eye but upon the death of his wife he would later marry her.

'...my picture is my stage, and men and women
my players exhibited in a "dumb" show.'
– WILLIAM HOGARTH

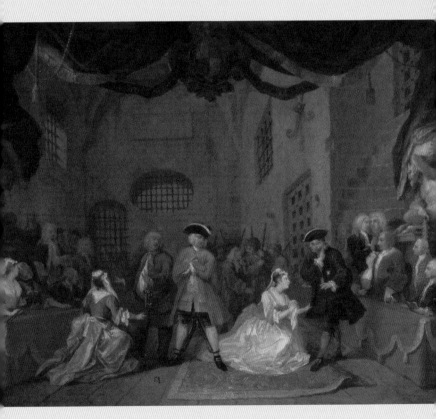

KEY INGREDIENT: The Lady in White

Snow Storm: Hannibal and his army crossing the Alps

J.M.W. Turner, 1812

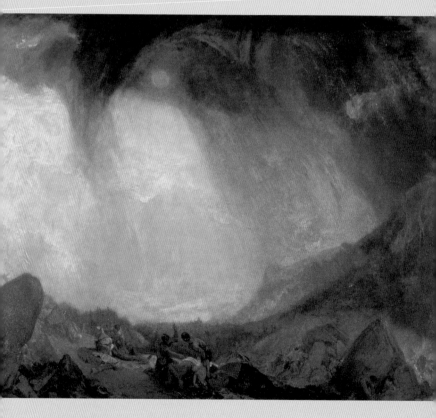

TASTING NOTES

As you stand in front of this large canvas you are sucked into the eye of the storm. Just below the blinding light you see the armies of the Carthaginian General Hannibal, crossing the Maritime Alps into battle, where they would beat the Romans by the River Ticino. The journey was arduous for his soldiers and for the elephants he took with him, one of which you can make out against the horizon. Stormy weather, which Turner himself had recently experienced in Yorkshire in 1810 and documented on the back of a letter, serves to highlight the dangers and treacherous nature of the journey. Turner is also evoking Napoleon's journey across the Alps at the Great St Bernard Pass in 1800. A stormy black sweeping cloud dominates the scene as an orange sun struggles to peep through. In the foreground you can make out local Salassian tribesmen murdering soldiers and others may well meet their death in the storm ahead. All the figures are small. They are at the mercy of the elements. Crusty paint is laid on thickly in areas of the canvas and swirling brushstrokes evoke terrible winds which might sweep even large elephants to their death. All are vulnerable in the face of Nature.

KEY INGREDIENT:
The Elephant

> 'My business is to paint what I see, not what I know is there.'
> – J.M.W. TURNER

The Ghost of a Flea

William Blake, c. 1819-20

TASTING NOTES

This gargantuan, nude, sculptural figure, in the form of a miniature, strides across a starry stage or is it a landscape? It is tempting to see this as a stage of imagination and visionary experiences; the stage of Blake's fertile mind if you like. The curtains suggest the scene is theatrical, as do the floorboards beneath his feet. The apparition seems spiritual, ugly and grotesque in its thick coat of dark tempera and brown paint made of gum, sugar and glue. Yet there are flickers of gold leaf which seem to sparkle like woven threads; some are white gold made from silver alloy and brushed into the paint. Blake believed that fleas were inhabited by the souls of men and left to go free, they could rampage, destroying human kind by drinking their blood. The figure holds an acorn and a thorn, and his venomous tongue juts out to feast on blood in a bowl. His murderous face and burning eyes strike fear into the viewer. Seen in Blake's lifetime as the work of a madman, it mirrors many of the ideas in his visionary poetry.

KEY INGREDIENT:

The Curtains

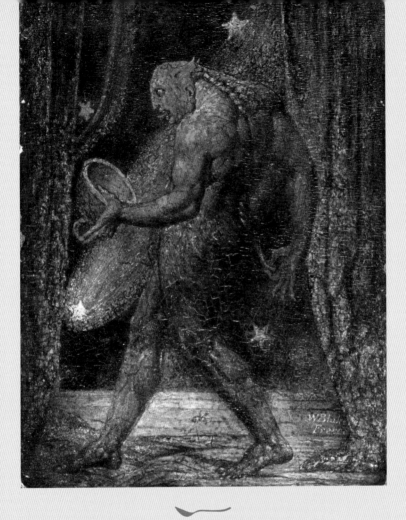

'…on hearing of this spiritual apparition of a Flea, I asked him if he could draw for me the resemblance of what he saw: he instantly said, "I see him now before me".' – JOHN VARLEY

The Opening of Waterloo Bridge

('Whitehall Stairs, June 18th 1817')

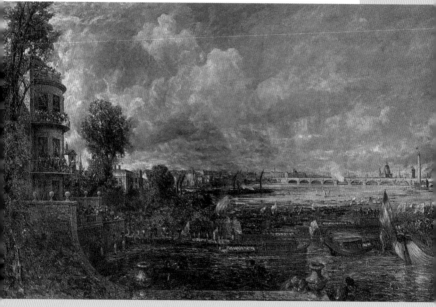

A Puff of Smoke

John Constable, 1819, exhibited 1832

TASTING NOTES

The view from the left is from Whitehall Stairs and the event happened on 18 June 1817 when Waterloo Bridge was opened by the Prince Regent (later King George IV) on the second anniversary of the Battle of Waterloo. John Constable probably witnessed the event as he had moved to London from Suffolk that year but he did not start working on this huge canvas (over 7 feet long) until 1819. It took thirteen years to plan and paint. As a staunch Royalist, Constable was keen to show the degree of pomp and circumstance of the occasion and the beauty of pageantry along the Thames, which can still be seen on occasion today. This he does, with sparkling bold brushstrokes of red, green and white and in areas, a thick build-up of paint laid on with a palette knife. However viewers can rarely get very close to events, which is why he chooses to distance us, while allowing us to marvel at the beauty of London's sites. The bridge, now destroyed and replaced in 1930, was grand and if you look carefully you will see a puff of smoke to the left of St Pauls' Cathedral. This is gun smoke signalling the firing of a gun salute to the Prince.

'When I sit down to make a sketch from nature, the first thing I try to do is to forget that I have ever seen a picture.' – JOHN CONSTABLE

Ophelia

John Everett Millais, 1851-2

TASTING NOTES

One of the most beautiful depictions of death, Ophelia's is described by Gertrude rather than shown on stage in Shakespeare's *Hamlet*. Out of her mind with grief over the death of her father, Ophelia has gone to a river in Denmark, climbed on to a branch and fallen in the water. Unaware of the danger and inured to discomfort, she floats while she sings. Her flowered garments billow around her and keep her afloat. Despite difficulties with insects and weather conditions, Millais painted by the river and depicted the beauty of the flowers which surround her. The attention to detail of the flora is ravishing. Your eyes will be drawn to the dots of red which enhance the green leafy bank. Ophelia holds a poppy, which, as an opiate, is a symbol of death and sleep. Her saintly pose, hands outstretched, palms upwards, suggests death is not painful but to be accepted and embraced. Millais' muse, Elisabeth Siddal, herself an artist, was said to have posed fully clothed in a bathtub and was later painted into the scene.

KEY INGREDIENT:

The Poppy

'…but long it could not be
Till her garments, heavy with their drink,
Pull'd the poor wretch from her melodious lay
To muddy death.'

– GERTRUDE IN *HAMLET*

The Awakening Conscience

William Holman Hunt, 1853

> 'Oft, in the stilly night,
> Ere slumber's chain has bound me,
> Fond memory brings the light
> Of other days around me;'
> – *OFT IN THE STILLY NIGHT*
> BY THOMAS MOORE

Her look we take in first. The look of revelation, of sudden awakening, of perhaps a sudden awareness that her life could be different or that she might be redeemable. She gazes out through a mirror on to the garden and freedom. Our eyes then take in the man on whose lap she has been sitting. She has no wedding ring, so she must be his mistress installed in a house where he can see her as he desires. His grasp is playful yet proprietorial, and he is relaxed in his fashionable attire and cufflinks. They have perhaps spent the evening playing and singing. The music we see is Thomas Moore's *Oft in the Stilly Night*. When we allow our gaze to roam around the room, we see a discarded glove, a tangled skein of yarn and a cat who toys with a bird with a broken wing. The woman is bird and glove, caught in a trap; even her dress is soiled, suggesting her future on the street if she does leave him, or worse, if she is outcast. We are left in doubt as to her immediate fate but in no doubt of what will befall her when he tires of her.

KEY INGREDIENT:

The Cat and the Bird

Past and Present No.1

Augustus Leopold Egg, 1858

Read all three paintings from this series and you will get a flavour of Victorian life and morality. A woman lies on the floor, her hands symbolically bound together as if shackled. Her husband holds a letter as proof of her crime – adultery. He crushes a miniature of her lover under his foot. Their older child looks across in horror as her house of cards, resting on a Balzac novel, collapses on the chair. Other symbols of the moral 'fall' are the apple cut in two, one half-stabbed to the core to represent the husband, who was to die five years later, and the mirror reflecting the open door the wife will have to take. In the other paintings in the series you will see the consequences of her act. The two orphaned girls – the mother gone and the father dead – sit in a stark garret comforting one another with images of their parents on the wall. The third takes place simultaneously, as we see from the moon, and shows the mother now destitute under the Adelphi arches, where women go when abandoned, holding her new child, the fruit of her adultery. Men could take mistresses in those days, but woe betide a woman taking a lover.

KEY INGREDIENT:

The House of Cards

'August the 4th – Have just heard that B – has been dead more than a fortnight, so his poor children have now lost both parents. I hear she was seen on Friday last near the Strand, evidently without a place to lay her head. What a fall hers has been!'

Subtitle – RA exhibition

Nocturne: Blue and Gold – Old Battersea Bridge

James Abbot MacNeill Whistler, c. 1872–5

The Rocket

TASTING NOTES

The reception of this painting was as explosive as the distant fireworks casting gold sparks across the sky. Part of a series of *Nocturnes*, Whistler took the art critic John Ruskin to court for his libellous comment that, with these works, Whistler was flinging a pot of paint in the public's face by asking for 200 guineas for each work. Whistler was awarded token damage of one farthing at court in 1878. The public also hissed when it was in the Christie's sale in 1886. It is evening along the River Thames and we see the old Battersea Bridge with Chelsea Old Church to the left and the new Albert Bridge in the background. Lights from houses and buildings cast reflections into the water. Whistler wished to align music with art, suggesting that a painting is a mixture of line, form and colour appealing to the eye, just as music is an arrangement of pattern and sound appealing to the ear. Influenced by Japanese art with its emphasis on decorative patterns and by Chopin's *Nocturnes*, we are invited to feel the mood and sensitivity of the scene and appreciate the flecks of gold falling from a rocket against the atmospheric blue of the sky and water.

'...the whole city hangs in the heavens,
and fairyland is before us.'

– JAMES ABBOTT MCNEILL WHISTLER

Carnation, Lily, Lily, Rose

John Singer Sargent, 1885–6

TASTING NOTES

Sargent and his friends would enjoy singing *Ye shepherds tell me* by Joseph Mazzinghi, and the title of this work comes from lines in the song. The setting is a garden in the village of Broadway, in the Cotswolds in England, which Sargent was visiting. Painted outdoors, he depicts two young girls, Polly and Dorothy, daughters of the illustrator Frederick Barnard, in the fading light of the evening, staring into lanterns which illuminate their little faces. Their clear fascination with the light shines in their red cheeks which contrast with their white dresses. Delicate, yet dazzling in texture of paint, Sargent has captured the artificial light of the Chinese lanterns which he had seen along the Thames, and the twilight hour in late summer, in this resplendent garden of lilies and light pink roses in full bloom. He lamented the brevity of time in a letter to his sister which made work slow, as each evening there were only about ten minutes when the light was perfect for the scene and he had to work well into the autumn.

'Fearful subject matter. Impossible brilliant colours of flowers, and lamps and brightest green lawn background.' – JOHN SINGER SARGENT

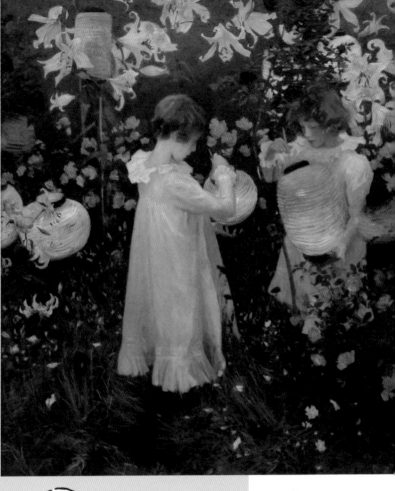

KEY INGREDIENT:
The Chinese Lanterns

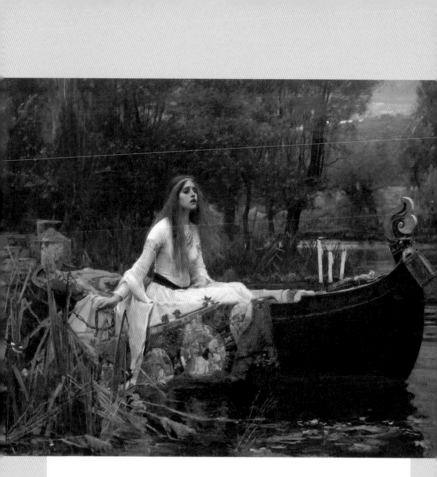

'She loosed the chain, and down she lay;
The broad stream bore her far away,
The Lady of Shalott.'

– ALFRED LORD TENNYSON

The Lady of Shalott

John William Waterhouse, 1888

TASTING NOTES

The cursed woman floats down the river from the island of Shalott to Camelot in a trance. Tennyson's poem, which Waterhouse had in his collection, depicts the woman who was locked in the tower on Shalott, down river from King Arthur's Castle and forbidden to look on reality, condemned to see the world through a mirror. When one day she spied the handsome Lancelot, she could not resist looking at him directly and the mirror cracked, the curse took hold and she was sent to her death on a decorated boat singing her last song. In the painting and the poem, she let go of the chain that linked her to her past and her dreams. She drifts to her death as she gazes upon a crucifix placed beside three flickering candles. Despite the ethereal quality of the work, the landscape is naturalistic and the work was done *en plein air*. The trees and reeds enclose her and the expression on her face is one of anguish and acceptance, perhaps abandon, as her glossy red hair is whisked by the wind.

KEY INGREDIENT:

The Chain

Royal Academy of Arts

'[The elected artist] shall not receive his Letter of Admission, till he hath deposited in the Royal Academy, to remain there, a Picture, Bas relief or other Specimen of his Abilities approved of by the then sitting Council of the Academy.'

THE INSTRUMENT OF FOUNDATION, ARTICLE III
10 DECEMBER 1768

With this mandate, the Royal Academy has amassed a collection of art that reflects its great history, but equally important was its mandate to encourage artists in Britain to aspire to future greatness. Since George III established the Royal Academy in 1768, it has chronicled growth and change, which you can now view in the permanent collection. You will see how artists learnt by returning to the Classical World in order to understand their contemporary world. Enjoy this 'taste of art' through time, noting the Crossing Worlds: how the art of the past influences the art of today and paves the way into the future.

Burlington House
Piccadilly
London W1J 0BD
www.royalacademy.org.uk

'I SAW THE ANGEL IN THE MARBLE AND CARVED UNTIL I SET HIM FREE.'

– MICHELANGELO

Draped female figure

Tasting notes

At first glance, what is so stunning about this torso is the drapery which seems to cling to the body as if wet cloth. It is astonishing to make marble appear soft and malleable; no wonder figures like this have inspired many artists to emulate. It makes us wonder whether this unknown figure relates to the sea? Perhaps the figure is Andromeda, who was sacrificed to a sea monster by her father King Cepheus but saved, so legend goes, by Perseus. Or she may be a sea nymph (Nereid) or a breeze nymph (Auras), and perhaps she adorned the Temple of Asklepios. She may well have been in a niche, as you can see little or no carving on the back. Attributed in 1927 to the Greek sculptor Timotheus, Bernard Ashmole also suggested she could be Europa who was carried to Crete by the God Zeus in the guise of a bull. Given to the Royal Academy by Henry Weekes in 1855, it is the only original Classical sculpture in the collection, although there is still a debate over whether it is a Greek original or a Roman copy.

Key ingredient:
WET CLOTH

Key ingredient: THE BIRD

Taddei Tondo

Tasting notes

This little beauty, typical of the Florentine Renaissance in its round format, is the only Michelangelo sculpture in a British collection. Although unfinished, it clearly represents the Virgin and Child with the infant St John, who is standing on the left and has his baptismal bowl strapped to his waist. He offers a bird to the Baby Jesus who appears to nestle further into His mother's lap to draw away from His cousin. This scene foretells later events in two ways: first, the position of Christ in His mother's arms after His death and secondly, the bird is thought to be a goldfinch, a symbol of Christ's suffering. In the Christian Legend, a goldfinch plucked one of the thorns out of His crown as He carried the cross. The Christ Child could be drawing away in fear and gripping tightly to His mother's arm, although he could also be being playful, as goldfinches were often kept as pets. The piece is unfinished as Michelangelo went to Rome at the time of making to work on Pope Julius II's tomb.

> 'BY SCULPTURE I UNDERSTAND THAT WHICH IS DONE BY THE SHEER FORCE OF TAKING AWAY; THAT WHICH IS DONE BY ADDITION IS SIMILAR TO PAINTING.'
>
> – MICHELANGELO

Design

In this work a female artist sits intently copying a sculpture, *The Belvedere Torso*, which is in the Museo Pio-Clementino of the Vatican Museum, Rome. A cast of the sculpture is also owned by the Royal Academy and included in this chapter. The artist is shown sitting at the base of two fluted Classical columns which evoke Culture. Nature is represented in the background. In the time of Kauffman's studies, it was possible to draw from Antique sculptures but as a woman, not from life models. This is one of four paintings done by the artist which represent Joshua Reynold's *Theories on Art,* given at The Royal Academy and published in 1788. They are called *Invention*, *Composition*, *Design* and *Colour*, representing both the practical and theoretical sides of art. They were first to be seen on the ceiling of the Royal Academy's Council Room and later transferred. This title, *Design*, relates to the Italian word 'disegno', which also means drawing. Perhaps the artist is commenting on the role of women artists at the time. We note the blue cloth next to the sculpture, suggesting that as a muscular torso of a male nude, it might usually be hidden from the eyes of female students.

Key ingredient: THE BLUE CLOTH

'THE GOOD ANGELICA HAS A MOST REMARKABLE, AND, FOR A WOMAN, REALLY UNHEARD-OF, TALENT; ONE MUST SEE AND VALUE WHAT SHE DOES, AND NOT WHAT SHE LEAVES UNDONE. THERE IS MUCH TO LEARN FROM HER, PARTICULARLY AS TO WORK, FOR WHAT SHE EFFECTS IS REALLY MARVELLOUS.'

– GOETHE

ANGELICA KAUFFMAN, 1778–80

Self-Portrait

Sir Joshua Reynolds was the founding member of the Royal Academy, a public figure and at the height of his powers when he painted this work. This portrait was painted to hang in the Assembly room of the Royal Academy when it moved to Somerset House under his direction. He stands before a cast after a bust of Michelangelo by Daniel da Volterra (1564–1566, Casa Buonarroti, Florence), in a pose reminiscent of Van Dyck and the composition echoes that of Rembrandt's *Aristotle contemplating a Bust of Homer* of 1653. With this self-portrait, Reynolds seeks distinction for himself but also clearly compares himself with some of the great names in art. In his written praise of the aforementioned Rembrandt, he notes 'little more than one spot of light in the midst of a large quantity of shadow'. Using masterly technique, he throws light on his own cheek and on his luscious red clothes as well as on the forehead of the cast of the great Michelangelo. His left hand rests gently and proprietorially on the cast, showing his affection and reverence. In it he holds documents, perhaps his own *Discourses*.

Key ingredient:
THE LEFT HAND

'I SHOULD DESIRE THAT THE LAST WORDS WHICH I SHOULD PRONOUNCE IN THIS ACADEMY, AND FROM THIS PLACE, MIGHT BE THE NAME OF MICHEL ANGELO'

– SIR JOSHUA REYNOLDS

JOSHUA REYNOLDS, C. 1780

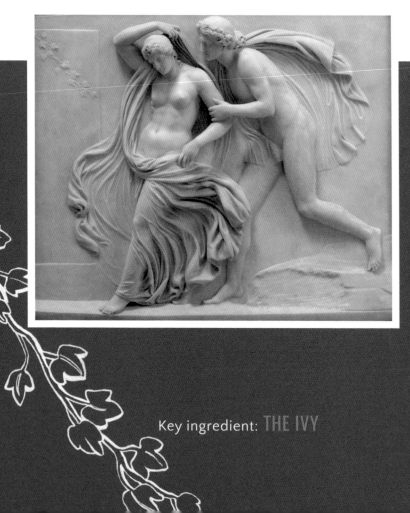

'...CONVERT THE BEAUTY AND
GRACE OF ANCIENT POETRY...'

– JOHN FLAXMAN

Key ingredient: THE IVY

Apollo and Marpessa

JOHN FLAXMAN, C. 1790–94

Tasting notes

John Flaxman, British sculptor and member of the Royal Academy, went to Rome between 1787 and 1794, emersing himself in the world of Italian sculpture and Greek vases. This work was presented to the Royal Academy in 1880 as his Diploma work. From his time in Italy he also produced celebrated illustrations to Homer and, indeed, many of his drawings and engravings are in the Library Print Room of the Royal Academy. In this sculpture Flaxman chose the moment when Marpessa, the Aetolian princess who had been spirited away by the great fighter and Messenian prince Idas, is then stolen by the great God Apollo. The relief does not show that after Zeus intervened and asked Marpessa to choose, she decided to stay with Idas, a mortal like herself who one day would grow old, rather than a god who would never age but would tire of her. It is difficult to assess where the scene took place, although a delicate sprig of ivy which trails across the outline of a column and the rocky ground beneath Apollo's feet situate the scene in both an earthly and physical space.

Cast of the Farnese Hercules

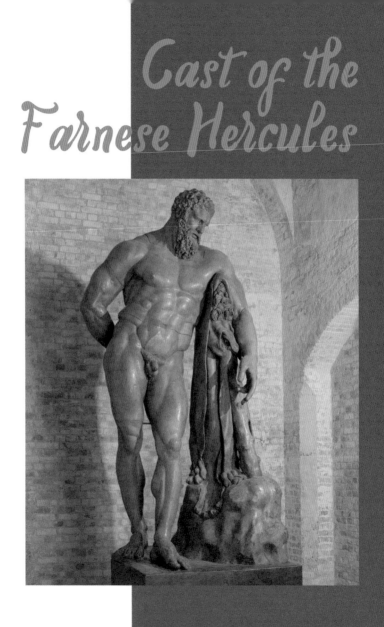

'…THE SHAMEFUL STATE OF *NUDITY*,
TO THE *TERROR* OF EVERY DECENT WOMAN
WHO ENTERS THE ROOM.'

– THE MORNING POST, 6 MAY 1780

Tasting notes

This cast, which was made for the Royal Academy Schools for students to copy, was shipped from Rome in 1790 and represents the mythological hero Hercules resting on his club, with the skin of the Nemean lion draped over it. Originally a Greek sculpture by the Athenian Glycon dated fourth century BC, a copy was made by a Roman sculptor called Lysippus in the third century AD. Hercules killed the lion as the first of his twelve labours. When the original sculpture by Glycon was discovered in the Baths of Caracalla in Rome in 1546 and later installed in a courtyard of the Palazzo Farnese, Rome, critics were concerned that the physique, with its 'superfluous masses of muscle', was too developed. Note that behind his back Hercules is holding three golden apples which he had stolen from the Garden of Hesperides, one of his last tasks. Making casts was often a way of preserving originals and students were able to study anatomy and musculature from sculptures such as these. This naked figure was seen as daring; the tiny hole visible in the lower stomach is where a fig leaf would have been hung for the sake of propriety.

Key ingredient: THE PIN HOLE

The Royal Academicians in General Assembly

'WHAT IS A WELL-CHOSEN COLLECTION OF PICTURES, BUT WALLS HUNG ROUND WITH THOUGHTS?'
– SIR JOSHUA REYNOLDS

This painting provides us with a valuable insight into the Royal Academy's collection in its first twenty-seven years and it played an important role in the promotion of history painting and in establishing the Royal Academy as an institution of high standing. On the one hand, the work looks like a document of a moment in 1795 when Royal Academicians are gathered to judge work in the Council Room at Somerset House. On the other hand, this painting tells us more about the aims of the Academy. In the foreground we see Academicians judging students' work. We can also see the plaster casts which helped them to learn to draw, most notably the *Belvedere Torso* and the *Laocoön*, both discussed in this chapter. Works by the eminent Royal Academicians are on the walls. We see Joshua Reynolds' *Self-Portrait* on the right and Angelica's Kauffman's *Design* on the ceiling. For the occasion, the first President of the Royal Academy, Sir Joshua Reynolds, painted large-scale portraits of the Academy's royal founders and patrons, George III and Queen Charlotte, who can be seen on the back wall presiding over the General Assembly in all their finery.

Key ingredient:
PATRONS OF
THE ACADEMY ON THE BACK WALL

'I PROFESS TO LEARN
AND TO TEACH ANATOMY
NOT FROM BOOKS
BUT FROM DISSECTIONS,
NOT FROM THE TENETS OF
PHILOSOPHERS BUT FROM
THE FABRIC OF NATURE.'
– WILLIAM HARVEY

Anatomical Crucifixion

Tasting notes

When medicine meets crime meets art. Until the Anatomy Act was passed in 1832, the only bodies legally allowed to be dissected were those of executed criminals. It was therefore important to learn anatomy from flayed figures or écorchés. In 1801, Academicians who wanted to deepen their understanding and solve their debate about what a real crucified figure would look like, approached an eminent surgeon, Joseph Constantine Carpue. He found a man called James Legg who had been sentenced for the murder of a pensioner called Lamb. After Legg was hanged on 2 November, the three Academicians, sculptor Thomas Banks and painters Benjamin West and Richard Cosway, were given the body, which they nailed to a cross to assess how Christ's body might have looked, and under Banks' direction a cast was made. A further cast was made after Carpue flayed the figure and this was used for medical students at St George's Hospital before being returned to the Royal Academy in 1917, where it hangs today. The first cast is lost.

Key ingredient:
THE CROSS

'...ABUSED AND MUTILATED IN THE EXTREME, DEPRIVED AS IT IS OF HEAD, ARMS, AND LEGS, THIS STATUE STILL APPEARS, TO THOSE CAPABLE OF LOOKING INTO THE MYSTERIES OF ART, IN A BLAZE OF ITS FORMER BEAUTY.'

— JOACHIM WINCKELMANN

Belvedere Torso

Tasting notes

This cast which appears as inspiration in several other works in the Royal Academy's collection, is believed to be copy by Apollonius of a Greek bronze original dating from the second century BC. The subject has uncertainly been identified as Hercules or Polyphemus, Marsyas or Ajax, all owing to the massiveness of the figure and its musculature, as well as the animal skin which is spread over the stone seat. This is thought to be a lion skin, although recent studies have suggested it might be that of a panther. Discovered in the fifteenth century and copied from about 1500 onwards, the *Belvedere Torso* has been one of the major inspirations of Classical revivals. Famously, Michelangelo refused to finish it. What we see is a man seated on a rock, headless and limbless. The upper torso is bending forward and to the right, while the rest of the body turns to the left. Ceded to the French in 1797, Napoleon entered Paris triumphantly with the sculpture in 1798 and it wasn't returned to the Vatican until 1816. Casts, such as this one, were presented to the Prince Regent as a gift from Pope Pius VII in gratitude for British diplomacy in facilitating the return of the original sculptures after they had been plundered by Napoleon.

Key ingredient:
THE ANIMAL SKIN

Here we have another cast received as a gift at the same time as the *Belvedere Torso*, although we have seen that Henry Singleton's painting of 1795 suggests the Royal Academy may have had an earlier version. The original was dated 100 BC to AD 50, said to be by Hagesandrus, Polidorus and Athenodorus of Rhodes. When it was found in the Palace of Titus at the Esquiline Hill in Rome in 1506, it joined the *Belvedere Torso* in the Villa Belvedere at the request of Pope Julius II. In Classical mythology, the priest Laocoön warned the Trojans against bringing a wooden horse presented by the Greeks into their city. The god Poseidon, who favoured the Greeks, was angry and sent sea serpents to strangle Laocoön and his sons. Although it is uncertain whether some figures have been added, the group is bound together by the winding sea serpents, and the contorted poses and facial expressions of agony have been the source of inspiration for students copying this work for hundreds of years.

Key ingredient:
SEA SERPENT

Laocoön and his Sons

'...OF ALL PAINTINGS
AND SCULPTURES,
THE MOST WORTHY
OF ADMIRATION.'

– PLINY THE ELDER

SOMERSET HOUSE
STRAND
LONDON WC2R 0RN
www.courtauld.ac.uk

THE COURTAULD GALLERY

A Modern World

TODAY STUDYING THE History of Art is
common practice, but it was a novel idea
as a university subject in early twentieth-
century Britain. A new Modern World was
emerging in the arts. Male and female
painters explored their daily lives and
engaged with contemporary themes in art.
Wanting to 'improve the understanding
of visual arts' and pave the way for 'art
history to enter the academic world', art
collectors, Samuel Courtauld and Lord
Lee of Farnham, along with art historian
Sir Robert Witt, founded the Courtauld
Institute in 1932. This gem of an art
museum, whose collection has been
primarily amassed through philanthropic
donors, is housed in Somerset House by
the River Thames.

PORTRAIT OF A WOMAN

Berthe Morisot, 1872–5

'I don't think there has ever been a man who treated a woman as an equal and that's all I would have asked for, for I know I'm worth as much as they.' – BERTHE MORISOT

THIS SLIGHTLY MELANCHOLY three-quarter view portrait, painted by the only woman artist to participate in the 1874 First Impressionist Exhibition, is probably of her sister Edma who later became Madame Pontillon, also a painter. In 1864 Edma had moved with her new husband to Brittany and wrote sad letters to her sister about her lonely fate. Her frothy white lace collar, the light sparkling on her jewellery and the brilliant contrast between the purple flowers and her cream-coloured garment with trimmings, seems strangely at odds with a fundamental lack of pleasure in her unflinching grey eyes. Light shines on her fashionable choker and pendant, picking up the colours of her corsage and earrings. She is adorned with hair decorations and rings on her anxiously clasped hands, yet her detached gaze seems to suggest a sadness; her wide eyes stare at you, her lips are slightly pursed. Later hailed as a great Impressionist for her brushstrokes and modern subject matter, Berthe Morisot, who married Manet's brother Eugène in 1874, was also criticised for the unfinished look of her canvasses and the rough texture which we see here in the incomplete grey wash of the background, which aptly makes her sitter seem trapped in this space.

key ingredient
THE CHOKER

LIVING IN THE increasingly industrialised town
of Argenteuil along the Seine, 11 kilometres to the
northwest of Paris, was still a joy for Monet in the
1870s. Enough of a rural idyll to attract day trippers
who could take the train from the Gare Saint-Lazare
and be there in 15 minutes, it provided a haven and
a respite from the busy city. Monet constructed a
floating studio boat and could paint the changing
lights outdoors with appropriate cover from the
elements. No black paint and no firm outlines enabled
the artist to create his mass of orange-brown leafy
trees with shape and contours. Enjoying varying
textures, sometimes he scratched into the surface,
creating grey marks on the right-hand side which
seem incised into the thick daubs of paint. Our eyes
are led to the town, as if we are floating effortlessly
towards it through a canopy of trees. On the horizon
line we spot the church spire, inviting us in, until
we see to its right, an echoing shape which is
a factory billowing smoke. There we have
it. The old rural France succumbing to
industrialisation. Even the new brilliant
autumnal colours Monet used were
made in factories.

key ingredient THE CHURCH

AUTUMN EFFECTS
AT ARGENTEUIL

Claude Monet, 1873

'Art is not what you see,
but what you make others see.'
– EDGAR DEGAS

TWO DANCERS ON A STAGE

Edgar Degas, 1874

NAPOLEON'S OWN PRIVILEGED box was to the right of the stage at the Opéra Garnier in Paris. You are perhaps not in his box, but you look down at the two waif-like dancers from the corps de ballet, rehearsing. In fact, the slightly vertiginous viewpoint highlights the empty space of the stage and the dancers are seen through the zoom-in lens of the viewer's binoculars. The skinny girls' scanty clothing and bare arms were scandalous for the English public, where the painting was first shown. Probably depicting, in a leafy setting, a ballet during the final act of Mozart's *Don Giovanni* to which Degas had access through his friend and collector Jean Baptiste Fauré, the painting contains a further mesmerising secret. The disappearing legs to the left are those of a man and the body is cropped. During this period, so many men sought the attention and perhaps favours of the young girls that they were limited to special days of the week. Frequently under-nourished, these girls in their rosy garlands and tutus are lit by the harsh lighting from the stage rim and their upturned faces half reveal a physiognomy purported to be that of the poor working-class girl.

key ingredient
THE MAN'S LEG

LA LOGE
Pierre-Auguste Renoir, 1874

YOU MIGHT WELL be watching this couple from another box at the opera or through your own binoculars. In her fashionable gown, the silk imported from Japan, inspired by an eighteenth-century creation called a *polonaise*, and her fan, the woman seems to stare into the middle distance, as if unaware of your attention. You own her briefly and can revel in her white-faced beauty; another reminder of Paris' penchant for Japanese culture due to recently opened trade. You can stare unabashed at her cleavage with its little nestling vial of fresh flowers or your eyes can roam to her pink lips. Your upwardly moving gaze follows the black lines of her dress and ends at the flowers in her hair. Her companion has perhaps spied a younger beauty and mirrors your gaze elsewhere. The shiny binoculars remind us that looking can be active and passive, furtive and blatant. Shown at the first Impressionist exhibition, this painting embodies the newly built Paris with its glittering array of delights on offer. Renoir's paint is luscious as is his confident, available, modern woman and her equally fashionable, predatory lover or protector.

key ingredient
BINOCULARS

 'She is a kind of idol, stupid perhaps,
but dazzling and bewitching'
– CHARLES BAUDELAIRE

A BAR AT THE
FOLIES-BERGÈRE

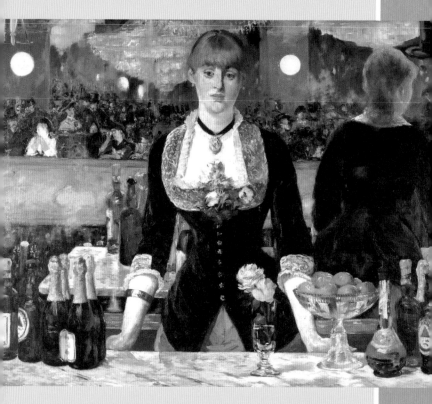

'...vendors of drink and love...'
GUY DE MAUPASSANT

Éduoard Manet, 1882

STARING BACK AT us is the model Suzon; she plays
the barmaid standing forlornly behind a gorgeous
array of bottles and flowers. You have wandered in
out of the night and asked, perhaps, for an English
bass beer. She would rather sell you crème de menthe
or a pink champagne or would she perhaps prefer to
get to know another furtive customer hogging her
attention? Her locket seems liquid, like her eyes,
the chandelier diffuses the light, whereas the new
electric lights sharpen the scene like two full moons.
You have stumbled across a wonderful venue. Look
at the crowd, all voraciously devouring each other
secretly with their binoculars. It's hard to see beyond
the mirror behind her. It is dirty and large smudges
waft across the scene and reflections seem distorted.
Have an orange; good for scurvy or even perhaps lean
in like he does and smell the flowers at her breast if
you dare. Watch out, look up and avoid the trapeze
artist! Precarious professions in
a precarious changing world; bar
maid and flying trapeze artist.
Step back a moment and remember
Manet, at the end of his life,
terminally ill yet still able to paint
this enigmatic masterpiece.

key ingredient
TRAPEZE ARTIST'S LEGS

WHAT COULD POSSIBLY have happened 23 December 1889 to have made Van Gogh take a razor and sever his entire ear? A letter from his beloved brother to tell him he was marrying? A substance-filled argument with Gauguin? If he gave the ear as a trophy-like present to a friend in a local brothel, how did she feel? Gauguin would flee back briefly to Pont-Aven, Van Gogh will spend time in the asylum at Saint-Rémy. We are left with a harrowing self-portrait, done looking in the mirror, so close to us that we step back in horror, aware that we witness pain and anguish. We know that within months Van Gogh will take his life and we search for clues. The Japanese woodblock print to the right depicts a sunlit floating world to which he does not belong. The easel behind him suggests he was working. The window is half-open, letting in a cold winter breeze and it is the look in his green eyes which fills us with pity, as well as the pallor of his skin and the furrowed lines which run down his face tracing the shape of the bandage; a cry for help from a tormented soul?

> 'I feel happier here with my work than I could be outside. By staying here, a good long time, I shall have learned regular habits and in the long run the result will be more order in my life.'
> – VAN GOGH, FROM THE ASYLUM

SELF-PORTRAIT

WITH BANDAGED EAR

Vincent van Gogh, 1889

'Art is a lie that enables
us to realise the truth.'
– PICASSO

UNCERTAIN SPACE; you might feel slightly
disorientated when you look at this. Cézanne reminds
you of the 'lie' that is painting and asks you to imagine
that if you were looking down or sideways or even
moving around the scene, the apple would not roll
down the table and the floor would appear curved. We
do not always stay still when we look, and we catch
glimpses of scenes. Here we are in Cézanne's
studio with his props and his paintings
leaning against walls. A still life of apples and
onions seems to fuse with a painting of the
same subject. Which is real and which is a
painting? He often used plastic fruits so
that they would not rot. Our eyes travel
up the plaster cupid, itself a copy of a
Roman sculpture or one by Puget, and
it seems to twist and turn. The arrival
of moving film and the new existence
of X-rays made artists consider how we
might depict movement on a still canvas.
The sculpture at the top, a plaster écorché, is
cropped. Our eyes have not yet explored that
far. This a ground-breaking radical work
which rejects conventional ways of seeing.

key ingredient CUPID

STILL LIFE WITH
PLASTER CUPID

c.1894

Paul Cézanne

NEVERMORE

Paul Gauguin, 1897

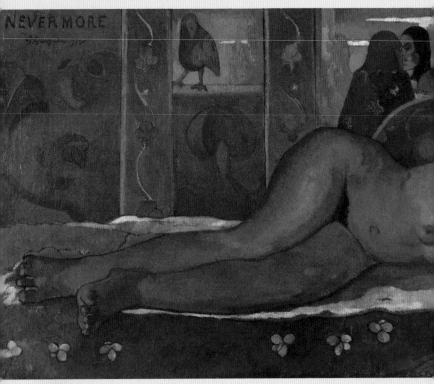

'Perhaps the bird had flown?'
– PAUL GAUGUIN

key ingredient
THE RAVEN

Gauguin knew the poem by Edgar Allen Poe called 'The Raven' as it had been recited at a dinner in 1891 just before he departed for

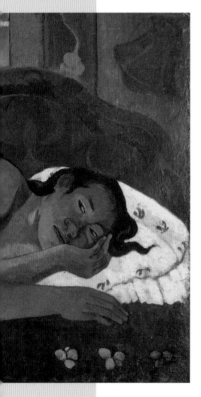

Tahiti. A bird visits a poet on a cold winter night and repeatedly croaks 'Nevermore'. The nude depicted here was Pahura, his current Tahitian 'vahiné' (wife). She lies half-awake on a bed. The yellow pillow shows off her brown skin, beautiful face and luscious young body. Gauguin was nearly fifty at this stage and had lived mostly in the Pacific for the past six years. His legal wife, Mette, was selling his paintings back in Denmark. He was infirm and needed taking care of. What strikes you next is the decoration on the bed and walls and then the two figures apparently deep in conversation at the back. The rhythmic quality of the painting is further enhanced by swirling shapes which echo her body, her curvaceous hips and rounded arms. Gauguin wanted the colours to appear sad and sombre and the bird is perhaps the devil who watches. The mood is strange and melancholic in this painting. The bird could fly off at any moment, as could Pahura.

AN EXTRAORDINARY MAN in so many ways, this collection must include Vollard. As one of the principal pioneering art dealers of the period who bought the Fauves and organised many shows for Cézanne, Renoir does not portray him as many others did; a boorish grumpy fellow. Renoir portrays him as a sensitive connoisseur appreciatively holding a small statue of a female nude and staring almost lovingly at it. The statue is Maillol's *Crouching Woman* (1900) and this inclusion may allude to Renoir's own interest in the sculptor's monumental classicism. The balding dealer, so important to many artists, is portrayed as a business man in brown apparel and white shirt, serious minded and astute in taste yet absorbed in his trade, caring not just for this sculpture but for other objects on the table which wait their turn. Renoir's palette is limited in this work but all the hues blend to give a soft focus to the man himself and portray him with attention to details, such as his tie and handkerchief in the jacket pocket. He is a wealthy man, intelligent and influential, and more importantly buys Renoir's work.

key ingredient
THE STATUE

PORTRAIT OF AMBROISE VOLLARD

Pierre-Auguste Renoir, 1908

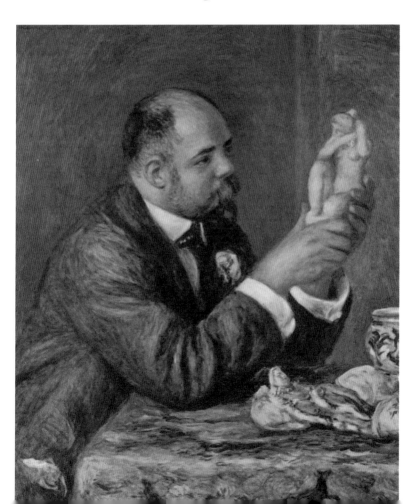

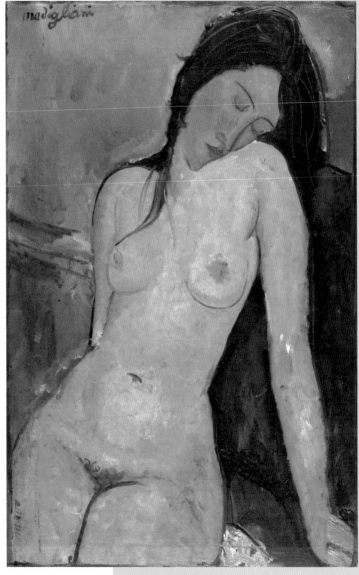

'With one eye, you are looking at the outside world, while with the other you are looking within yourself.' – MODIGLIANI

FEMALE NUDE

Amedeo Modigliani, 1916

THIS SCULPTURAL AND primitive nude, like the Oceanic, African and Egyptian sculpture so popular at this time and collected by many artists, stands quite apart from a long tradition of nude figures. Her head on one side and her sleepy features were popular in depictions of the model. Vulnerable yet strong, her body is exposed as she partly reclines with one wisp of hair falling onto her right breast. Modigliani's brushstrokes are short and sharp, and an X-ray will reveal that they are scallop-shaped. Wet paint has been manipulated to give contours and simulate flesh. In her left arm are bare patches and evidence of the use of the end of the brush to scratch into the surface. Her body is painted in various shades of pink and her face seems flushed. The audience and critics were shocked by the visible pubic hair. When the painting was first shown at the Berthe Weill Gallery in Paris, in 1917, the police ordered that none of the paintings should be seen from the window. Later the exhibition was closed. Nudes were popular but not the sight of pubic hair, which was taboo.

key ingredient PUBIC HAIR

Tate

Bankside
London
SE1 9TG
www.tate.org.uk

Modern

The former Bankside Power Station, designed by Sir Giles Gilbert Scott, who also designed the iconic red telephone box, became the home of Tate Modern on 11 May 2000. It is the home of national and international contemporary art. In the increasingly technological twentieth century a Brave New World was growing and developing, paving the way for visual experimentation in all the arts. The building itself is a work of art. Don't miss the Turbine Hall, a social and ever-changing space in the original gallery or the off-kilter pyramid design of The Switch House, the new wing opened on 17 June 2016.

Mandora

GEORGES BRAQUE, 1909–10

Picasso and Braque, great friends and artistic allies, popped into each other's studios and contemplated their shared drive to see and represent the world in a different way. Focusing on the difficult problem of how we view a three-dimensional world on a two-dimensional canvas, they created a new pictorial language. Here, the musical instrument is decipherable through signs such as chords and fret or sound hole. We know what we are looking at, but we see the object without any context. There is no room or surface to anchor us, no person who plays the instrument. We have music alone, the most abstract of all language. Sound waves seem to emanate from the instrument, which literally seems to quiver and vibrate. This was a ground-breaking piece and although Picasso was doing similar things, Braque's background as a house painter gives this piece a textural feel. Go beyond the musical instrument and you will see that all the surrounding area seems to respond to it, vibrating and quivering right out to the edges of the canvas which then becomes blurred, mirroring the way we see.

} *'We were like two mountaineers roped together.'* – BRAQUE

Cossacks

WASSILY KANDINSKY, 1910-11

TASTING NOTES

This painting seems to hover on the edge of Abstraction. However, the landscape is recognisable and there are what the Russian artist, Kandinsky, called 'traces of the object'. We can make out three cavalrymen with orange/red fur Cossack hats, riding on horses which seem to be locked together in the foreground, just in front of a rainbow which forms a bridge with jagged mountains in the background and perhaps a flock of birds in the sky. The men carry lances or sabres which they appear to be brandishing, suggesting an apocalyptic battle. There may even be guns firing and smoke in the air, all represented with the minimum of detail, a lack of conventional perspective and the use of primary colours which form patterns and designs rather than narratives. The composition is filled with restlessly strong diagonals, menacing black lines and notations which suggest music. Kandinsky preferred the title Cossacks but the painting has variously been called Improvisation 17, Battle and Fragment for composition 4. He had been aware of the strikes in Odessa a few years earlier and the need for engagement with our spiritual world while the modern technological world took hold.

'*The artist must train not only his eye but also his soul.*' – KANDINSKY

key ingredient: Cossack Hats

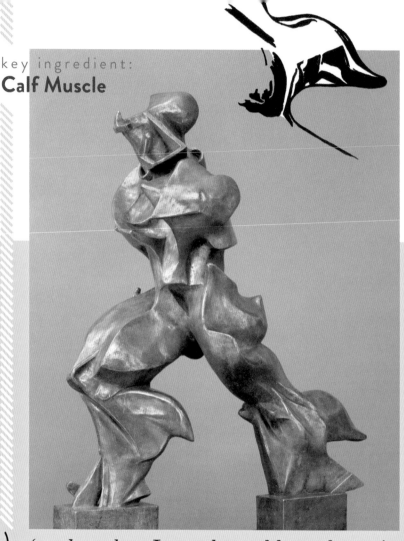

'*...these days I am obsessed by sculpture!
I believe I have glimpsed a complete
renovation of that mummified art.*'
– BOCCIONI

Unique Forms of Continuity in Space

UMBERTO BOCCIONI, 1913, CAST 1972

Is this a winged Pegasus or a Nietzschean superman striding out fearlessly through space into the future, his flesh and particularly his calf muscles quivering with the speed of his pace? Or does it resemble the Victory of Samothrace, which the Futurist artists saw as mummified art? The Italian artist Boccioni was part of the Futurist movement and, at 114cm high, this is his excited response, expressed in bronze, to mechanisation and industrialisation. The very 'throbbing soul' and dynamic sensation of the new motor cars and flight, both of which encouraged their excitement with speed, are evident in this wind-swept unknown figure which is also sleek and modern. However, what is so extraordinary about this sculpture is both the beauty of line and the artist's ability to render speed with such a hard material as bronze, although it was never cast into bronze during Boccioni's lifetime. The figure seems to march. Created one year before war broke out, a war which the Futurists embraced initially, the sculpture seems prophetic, as machinery and robotics were already of paramount importance. This sculpture embraces the future and the urge to progress, and it quite literally moves forward.

Fountain

MARCEL DUCHAMP
1917, REPLICA 1964

TASTING NOTES

A urinal placed on its side; is it Art? When Duchamp submitted this piece in the 1917 show for the Society of Independent Artists in New York, it was rejected but we are lucky that Alfred Stieglitz took a photo as it was 'lost' immediately after. It is of course replaceable. It is the idea of it which matters more than the materials. Porcelain, albeit an expensive material, is durable and strong but once you turn such an object on its side it loses its original function. We question perhaps its value and its aesthetic appearance. We particularly question the notion that once it is placed in an art gallery, does that immediately justify its role as an object to be stared at, to be revered, to be considered skilful? The irony is clear. We are left wondering who R. Mutt might be; is it a play on the name of the factory or does it relate to the German for poverty, 'Armut'? In an age where signature validated the idea of authenticity, we are left reconsidering the role of art. Duchamp has posed many questions in displaying this piece, but like any philosophical dilemma he gives us no answers.

R. Mutt
1917

key ingredient: The Signature

'One of my female friends, who had adopted the pseudonym Richard Mutt sent me a porcelain urinal as a sculpture...' – DUCHAMP

'Dora for me was always a weeping woman... And it's important as women are suffering machines.' — PICASSO

Weeping Woman

PABLO PICASSO, 1937

TASTING NOTES

By the end of 1937 Picasso had completed a series of works responding to the Spanish Civil War and especially the bombing of the little town of Guernica by the German pilots. The image of mothers and girlfriends suffering the loss of their men during this time is fused for Picasso with the image of The Virgin Mary and the loss of her son. By this time, Picasso was living in France and had met the photographer Dora Maar in 1936. She was the only one allowed to photograph the stages of painting the monumental canvas of *Guernica*. Their relationship was volatile, and he saw her too as a weeping woman. In the painting Dora wears a brightly coloured hat and carries a handkerchief. Her eyes are bright, and her bared teeth stress the anguish of the moment. Her features seem drawn but her long dark eyelashes and painted nails reaffirm her presence. The lurid colours, so different from the larger painting of *Guernica* itself seem to mock the grief, as does the flower in the elaborate hat.

key ingredient:
The Hat

Metamorphosis of Narcissus

SALVADOR DALÍ, 1937

In the Greek myth Narcissus loved only himself and hurt all his lovers, so the Gods punished him by letting him see his own reflection, inevitably falling in love with himself and dying of frustration. The Gods relented and turned him into a flower, a narcissus or daffodil. Dalí, using his meticulous technique, which he called 'hand painted colour photography', shows Narcissus twice, transformed into a severed hand holding an egg with a flower sprouting out of it, a symbol of rebirth, and then again before his transformation in the background. The hand is mirrored by another more sculptural hand on the other side of the pool of water. Dalí was proud of the work and took it to show Freud when he met him. The extraordinary clarity of the work, due largely to Dalí's techniques of painting, seems to lie in opposition to the dream world of Surrealism which interested Dalí, but this is precisely what he called his 'paranoic critical method'. The brightly lit landscape is both an illusion and a deception. The sky, water and vegetation seem to belong to a naturalistic world, but the figures and sculptures seem dreamlike.

'*When that head slits*
when that head splits
when that head bursts,
it will be the flower,
the new narcissus.' — DALÍ

key ingredient:
The Flower

'I could, for the rest of my life, take an egg form and in different materials carve an infinite number of sculptures all giving [a] different sort of "life".' – BARBARA HEPWORTH

DAME BARBARA HEPWORTH
1943, CAST 1958

Oval Sculpture (No. 2)

TASTING NOTES

This plaster ovoid, just like an egg, makes you think of a human or bird's head, yet it also references Hepworth's growing love of the Cornish landscape to which she had moved just before World War Two. Carved from a wooden original, and then cast twice in plaster, her work had always demonstrated an interest in circles and spheres but now this oval shape lies within and without, giving eyes and a face to a geometric form which in turn makes us think of shells, caves and eroded rocks. The inner ovoids seem to carry an expression in their eye-like form, which echoes the outside shell or carapace. Hepworth felt the piece related to an 'origin' or 'source', in that it could be both primitive and foetus-like. Figurative and abstract at the same time, Hepworth's skill lies in the complexity and simplicity of this piece. Aware of psychoanalytic theory, she is perhaps likening the making of the work of art to childbirth and regeneration, just as the rocky Cornish landscape with its bays and coves is both permanent and ever-changing.

key ingredient:
The Inner Ovoids

TASTING NOTES

Enter this room and leave the world behind you. Move around it and look carefully at all nine large canvases before you eventually come to rest on this one. Take a deep breath and stare straight into the middle of the work, noticing that you have a maroon frame which seems to shimmer the more you look at it. The effect of the silvery grey paint within the frame and without it gives depth, taking you in and keeping you there, willingly trapped. Notice too that the lighting in the room is sombre and your mood will become increasingly meditative. This unframed canvas contains a frame within, or is it a window through which you peer and see what you want to see? Initially intended for the exclusive restaurant of the Seagram Building in New York, Rothko changed his mind when he saw the room and eventually sent the works to Tate with very specific instructions on how he wanted them to be hung. He claimed he was influenced by Michelangelo's walls in the Medicean Library in Florence and wanted viewers to feel trapped in a room where all the windows and doors are bricked up.

key ingredient:
The Inner Frame

Red on Maroon

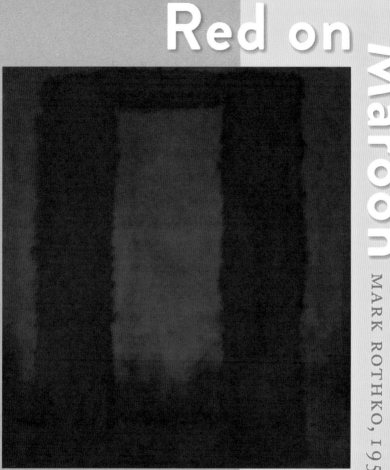

MARK ROTHKO, 1959

'To paint a small picture is to place yourself outside your experience… However, you paint the larger picture, you are in it. It isn't something you command.' – ROTHKO

Triptych

SONIA DELAUNAY,
1963

TASTING NOTES

One of the pioneers of Abstraction, this Ukrainian-born French painter described herself as 'earthy' and wanted this work to have something sensual and abstract at the same time. Delaunay was interested in the colour theories of Michel Eugène Chevreul and the effects of colour when they are simultaneous. In this work, colours respond to and heighten one another. Bright reds respond to greens of varying hues and blues which are light and dark. They all revolve around the white centre and the canvas is divided very loosely into three, hence the title. What is most apparent in this work is the design of the composition. Delaunay's interest in textiles informed her painting and her designs for costumes for the Ballets Russes. This work was created in her studio in Paris and there is no under-drawing, but the viewer is aware of brightly coloured discs, squares and triangles which form the geometric quality of the work. This is an oil painting and if you get close you will notice the different textures and surfaces of the blocks of colour laid on to the canvas with brushes and palette knives.

'...this is a painting on which I worked a great deal, and which opened up new vistas for me.' – SONIA DELAUNAY

key ingredient:
The White Centre

Spider

LOUISE BOURGEOIS, 1994

TASTING NOTES

This huge arachnid cannot fail to have an effect as you walk into the room. Perhaps at first glance you recoil from a creature which so often evokes fear and mistrust, yet the sheer size reminds you this is a sculpture and you draw near in awe of the beauty. The French-born American artist Louise Bourgeois remained interested in her study of spiders all her life and likened them to her mother, of whom she had been inordinately fond. Describing her mother as her best friend and someone who never answered stupid or distressing questions, she reminds us that the other link is that her mother was a weaver. Made of bronze and granite, notice the cage structure which contains an egg which is well protected and ensures the continuation of the species. All eight spindly legs are attached to a cylindrical structure just above the cage, giving you the feeling that the large graceful arachnid is crawling. You suspend disbelief as you know it can't harm you but how close do you go? A recurring theme in large bronzes and small drawings, one of her other spiders, called *Maman*, was made for the opening of Tate Modern and displayed in the turbine hall.

key ingredient:

The Egg

'*My work disturbs people, and nobody wants to be disturbed.*'

— LOUISE BOURGEOIS

Facing the World

10: National Portrait Gallery

THE GOOD AND the great are all on display in the most extensive collection of portraiture in the world. The gallery was opened in 1856 with the aim 'to promote through the medium of portraits, the appreciation and understanding of the men and women who have made and are making British history and culture, and to promote the appreciation and understanding of portraiture in all media'. Enjoy our selection of iconic portraits of men and women, staring out of the canvas. They are Facing the World in this very special museum.

St Martin's Place
London
WC2H 0HE
www.npg.org.uk

'I hate the idea of success robbing you of your private life.' – Paul McCartney

Paul McCartney ('Mike's Brother')

SAM WALSH, 1964

THE IRONIC SUBTITLE states clearly the relationship between the artist and the portrait of one of the most famous popular singers of all time, and member of the group called The Beatles. Sam Walsh was indeed more of a friend of McCartney's brother Mike. By 1964 Beatlemania had taken hold with songs such as *She Loves You* and *I Wanna Hold Your Hand*, not just in The Cavern in Liverpool but by then much further afield. Sam Walsh, Mike's friend, and later a graduate of Dublin College of Art, was later to say that he painted the portrait in lieu of bringing a bottle to a party. Done in oil on Masonite, the portrait is intimate, as the sitter is so close to the picture plane you feel he is peering at you and talking to you in an animated way. You feel he cares about you. His brown eyes gleam with obvious energy and joy, his teeth are white, his flesh pink and heavily textured, and his signature haircut is visible. Overall, despite fame then and even greater to come, the portrait suggests that McCartney remains a friendly lad from Liverpool who you are chatting to, feeling as if you know him.

Key ingredient:
Brown Eyes

'I did not want to paint her as a film star; I saw her as a monarch, alone in the problems of her responsibility.'
– Pietro Annigoni

Queen Elizabeth II

PIETRO ANNIGONI, 1969

PAINTED IN TEMPERA grassa on paper on panel, this full-length portrait of the young Queen Elizabeth II shows a low skyline with almost no other background detail to take us away from the extreme dignity of the woman standing alone, bedecked with finery, yet looking vulnerable and serious. Her three-quarter gaze is not for us; it is suggestive of the huge responsibility of her position and her awareness of her task. The light on the horizon line glows as if to suggest a new dawn. It also breaks the starkness of the background blue colour. Annigoni had painted her before in 1954, so was specifically asked by the Monarch to do this portrait. It was paid for by the art dealer Sir Hugh Leggatt and took over eight months to complete. Dressed in the robes of the Order of the British Empire, displaying her medals against the red cloak, the artist has emphasised her importance and possible loneliness in her dauting life-long task. The portrait was not popular at the time but Annigoni went on to paint her several more times, so she must have appreciated his viewpoint.

Key ingredient:
The Blue Medal

Elton John ('On the throne')

SUZI MALIN, 1978

PAINTED IN TEMPERA over gold leaf on gesso prepared board, Suzi Malin gives us a view of the famous singer, composer and musician, which both suggests his role as the flamboyant King of Pop and serious Member of the Royal Academy. As a cultural icon since the 1970s, whether in football at Watford Football Club or at The Old Vic, he even sang at Diana, Princess of Wales' funeral. He produced regular Top 40 singles between 1970 and 1996. He has never disappeared from public awareness and is still a great favourite amongst many. In 1978 he was at a high point in his career when Malin, who studied at the Slade School of Art, met him through his manager who had bought her portrait of Hockney. She paints John in this portrait in a slow fresco technique of great beauty. A brown background with two angels etched into it crowns him and he, too, has angel wings on his flamboyant white suit. His gaze, behind rose-tinted glasses with diamond frames, makes us consider whether he is looking at us or we are looking at him. Malin has nine other portraits in this gallery.

Key ingredient:
Pink Glasses

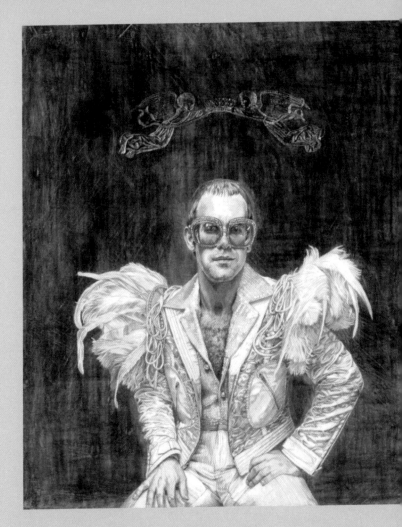

'The great thing about rock and roll
is that someone like me can be a star.'
– Elton John

Diana, Princess of Wales

BRYAN ORGAN, 1981

THIS PORTRAIT WAS unveiled just before Lady Diana Spencer married Prince Charles. Aged only just twenty, she is portrayed sitting in a demure but sideways position on an elegant chair in the Yellow Drawing Room, one of 750 rooms in Buckingham Palace. This informal portrait seems to mock the formality of the occasion but perhaps it is difficult to look at this painting without recalling the events that would follow. Placed in front of the door, it is tempting to believe that she knew she would leave, yet her direct glance at the painter and at us shows trust and friendliness as she embarks on a new life.

Bryan Organ was no stranger to royal portraits, creating a symmetrical portrait with decorated flowered wallpaper suggesting her sweetness and pungency, simple clothes with just a hint of a frill in her collar and stripes on her jacket which match the gold panelling on the door itself and above. Ironically, although she seems to fit in to her surroundings and seems at ease, she grasps the side of the chair nervously, giving us a hint that the task ahead was daunting.

Key ingredient:
The Chair

'I wear my heart on my sleeve.'
– Diana, Princess of Wales

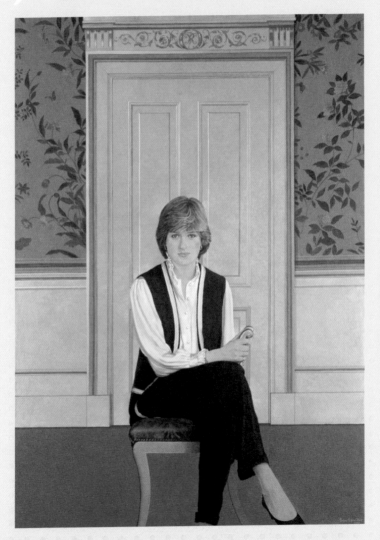

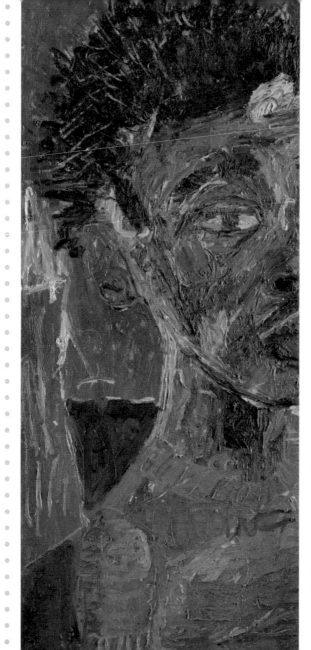

'I'm aware that success can overwhelm you. The perception of you can be elevated to such a status that it's not you anymore.' – Chris Ofili

Self-Portrait

CHRIS OFILI, 1991

IT IS RARE to see a self-portrait in Chris Ofili's work. This stark view of himself, done probably as he looks in a mirror, shows a fascinating insight into the role of painter, especially when faced with the task of representing the face he knows best. This work was done before he gained success, when he was still a student at the Chelsea College of Arts. The narrow frame allows Ofili to peep at us and into the canvas shyly, as if he has not yet confirmed his position as painter. In fact he was awarded a CBE in 2017 for services to art. His Nigerian features are recognisable, and the black skin colour is enhanced by the green sweater he wears. The acrylic paint is thickly laid on so that it almost forms a skin over the canvas. His one visible eye seems to scrutinise himself and us as we look at him. Painters often have to use a mirror to paint themselves and the act of focusing on the canvas and the mirror at the same time takes concentration. This is the glance he captures: the painter at work.

Key ingredient:
The Eye

'A portrait that is kind is
condescending. The last thing
I would want is for Paula to
condescend to me, and it's the last
thing she would think of doing.'

– Germaine Greer

Germaine Greer

PAULA REGO, 1995

THE FIRST THING that will strike you about this portrait is Greer's pose. As a long-term supporter of Rego's work, she sits in the artist's studio in Camden Town and leans forward, as if engaged in conversation. Her head is tilted slightly to suggest intense listening and her eyes shine as they look at someone. It's not at you but you feel part of the conversation. She perches on the end of a low sofa, legs spread out and feet touching as are her hands, roughened by gardening. Her shoes are gold and the left one looks in need of mending. Greer is an academic and public advocator of feminism, and the suggestion is that her thoughts are more interesting than the condition of her shoes. Her dress, however, is by her favourite designer Jean Muir and the red forms a great contrast with her skin tones, unruly hair and shoes. Greer sat for thirty hours and they listened to Wagner's *Ring Cycle*.

Key ingredient:
The Left Shoe

A.S. Byatt

PATRICK HERON, 1997

DAME ANTONIA SUSAN Byatt is a writer and poet and won the Booker Prize for Literature in 2008. She chose Patrick Heron to paint her shortly before he died, as she wanted something colourful and abstract. On her first visit he drew her, and she recognised the moment the writer faces the blank page as similar to the experience of the painter. She sat in his studio in St Ives for three days and recounts how she felt when she saw the finished work. Delightedly she discovered that, what he had painted was exactly how she felt when she began writing; 'a vanishing, watching body in a sea of light and brilliance'. Five colours work together: blue clothes made of daubs of paint, blocked orange background on the right, green interspersed and yellow above her pink face. Her expression is lightly sketched, as if it may change any moment. The painting has energy and dynamism, and it is easy to see why she might have been pleased.

Key ingredient:
The Face

'What I wanted was the presence of the idea of me, not of a record of the whole of my face that I don't much like.'
– A.S. Byatt

J.K. Rowling

STUART PEARSON WRIGHT, 2005

THE FAMOUS WRITER
of one of the biggest global phenomena, Harry Potter, Rowling sits in a tiny claustrophobic space reminiscent of a box or cage. We think of Alice in Wonderland, too big for the space she inhabits. Rowling sits at a desk which reminds us of the café in Edinburgh where she began to write as a struggling student. She does not look out of the window at the blue sky but stares, straight-faced, out of the canvas into the distance, as if thinking about her characters. The walls are bare except for a light switch and a small radiator. The spikey pot plant suggests some notion of a domesticated interior, except it does not seem to belong and looks clearly out of place, a product of her imaginary world. Rowling sits at a breakfast of eggs and toast. The three eggs represent her three children and her private life which she guards carefully despite media frenzy. Her bare feet and simple but alluring white dress are also reminders of her humble beginnings and then her extraordinary fame.

Key ingredient:
The Eggs

Catherine, Duchess of Cambridge

PAUL EMSLEY, 2012

THE DUCHESS SAT twice for this portrait. The process of painting took Paul Emsley, an artist chosen by the duchess herself and who had already won the BP Portrait Award, fifteen weeks. She sits very close to the picture plane and is painted over life-size. Her green blouse brings out the colour in her eyes and her half-smile is enigmatic, as if it would be impossible to share her thoughts. The background blends with her blouse colour and does not detract from her face. Her eyes sparkle. Her hair frames her face and the presence of one earring, once a favourite of Diana, Princess of Wales, and given to Kate as a wedding gift from William, is her only adornment. stressing her natural looks rather than her status as a duchess and paying homage to the future king's late mother. This portrait was criticised on the day of unveiling although the duchess herself seems to have appreciated it. Critics said it was 'gloomy, vampiric and even depressing'. She, however, said it was 'amazing'.

Key ingredient: The Earring

'I'm interested in the landscape of the face, the way in which light and shadow fall across the forms. That's really my subject matter.'
– Paul Emsley

Ed Sheeran
COLIN DAVIDSON, 2016

COLIN DAVIDSON, AN Irish visual artist commented that it was very important when doing this portrait to avoid presenting Ed Sheeran performing. As Sheeran is a successful singer who regularly performs, Davidson wanted to capture him as naturally as possible and this he does. He got the commission through Sheeran's father, who is an art historian. The face is large; the canvas is 4-foot square on linen. His red hair and beard frame his face and dominate the picture, although his eyes, which are blue, are slightly dewy, giving them a glint but also an expression of great humanity and seriousness for someone who is and was very young. His green sweater is reflected in the strands of his beard and his mouth is set to a straight line. He looks out of the canvas as if caught unawares. Davidson's aim was to highlight the young man's creativity.

'When painting a portrait, I am looking for the moment when the person is almost unaware of me being there and I feel I got it with Ed.' – Colin Davidson

Key ingredient:
The Eyes

Gallery Checklist

**Use this list to plan your travels
and tick off the ones you find...**

1. The British Museum – An Emerging Britain

- **Vindolanda Tablets**, AD 85–130
- **Bronze Head of Hadrian**, AD 117–38
- **Ribchester Helmet**, first century AD
- **Uley Mercury**, second century AD
- **Corbridge Lanx**, fourth century AD
- **Hoxne Pepper Pot**, AD 300–400
- **Hinton Saint Mary Mosaic**, early fourth century AD
- **Mildenhall Great Dish**, fourth century AD
- **Lycurgus Cup**, fourth century AD
- **Sutton Hoo Helmet**, early seventh century AD

2. The V&A – A Spiritual World

- **The Easby Cross**, c. 800–820
- **Casket**, 961–5
- **Tabernacle**, c. 1180
- **The Syon Cope**, 1310–1320
- **The Saint Denis Missal**, c. 1350
- **Prophet Ezekiel flanked by Saints John the Evangelist and James the Less**, c. 1393
- **Misericords with Harvest Scenes**, 1375–1400
- **Devonshire Hunting Tapestry – Boar and Bear Hunt**, 1425–30
- **Three Figures from Naworth Castle**, 1470
- **Christ sitting on an Ass**, c. 1480

3. The National Gallery – New Perspectives

- **The Arnolfini Portrait**, Jan van Eyck, 1434
- **Baptism of Christ**, Piero della Francesca, after 1437
- **Venus and Mars**, Sandro Botticelli, c. 1483
- **The Virgin of the Rocks**, Leonardo da Vinci, 1491/2 and 1506–8
- **The Entombment**, Michelangelo, 1500–1
- **The Madonna of the Pinks**, Raphael, 1506–7
- **Bacchus and Ariadne**, Titian, 1520–23
- **The Ambassadors**, Hans Holbein the younger, 1533
- **The Supper at Emmaus**, Caravaggio, 1601
- **The Rokeby Venus**, Velázquez, 1647–51

4. Dulwich Picture Gallery – A Theatrical World

- **Samson and Delilah**, Anthony van Dyck, c. 1618–20
- **Saint Sebastian**, Guido Reni, c. 1630–35
- **The Triumph of David**, Poussin, c. 1631–3
- **Venus, Mars and Cupid**, Sir Peter Paul Rubens, c. 1635
- **Girl at a Window**, Rembrandt, 1645
- **Landscape with Windmills near Haarlem**, Jacob van Ruisdael, mid 1650s
- **A Road near a River**, Aelbert Cuyp, c. 1660
- **Three Boys**, Bartolomé Esteban Murillo, c. 1670
- **A Woman playing a Clavichord**, Gerrit Dou, c. 1665
- **Jacob with Laban and his Daughters**, Claude Lorrain, 1676

5. The Wallace Collection – An Enlightened World

- **Voulez-vous Triompher des Belles?** Jean-Antoine Watteau, c. 1716–18
- **A Young Woman in a Kitchen**, Nicolas Lancret, c. 1720–25
- **The Riva degli Schiavoni**, Canaletto, 1740–45
- **Santa Maria della Salute and the Dogana**, Francesco Guardi, 1770s
- **Madame de Pompadour**, François Boucher, 1759
- **The Broken Mirror**, Jean Baptiste Greuze, c. 1762–3
- **The Swing**, Jean-Honoré Fragonard, c. 1767–8
- **The Avignon Clock**, Pierre Gouthières, 1771
- **Mrs Mary Robinson: Perdita**, Thomas Gainsborough, 1781
- **Madame Perregaux**, Élisabeth Louise Vigée Le Brun, 1789

9. Tate Modern – A Brave New World

- **Mandora**, Georges Braque, 1909–10
- **Cossacks**, Wassily Kandinsky, 1910–11
- **Unique Forms of Continuity in Space**, Umberto Boccioni, 1913
- **Fountain**, Marcel Duchamp, 1917
- **Weeping Woman**, Pablo Picasso, 1937
- **Metamorphosis of Narcissus**, Salvador Dalí, 1937
- **Oval Sculpture (No. 2)**, Dame Barbara Hepworth, 1943
- **Red on Maroon**, Mark Rothko, 1959
- **Triptych**, Sonia Delaunay, 1963
- **Spider**, Louise Bourgeois, 1994

10. National Portrait Gallery – Facing The World

- **Paul McCartney ('Mike's Brother')**, Sam Walsh, 1964
- **Queen Elizabeth II**, Pietro Annigoni, 1969
- **Elton John ('On the Throne')**, Suzi Malin, 1978
- **Diana, Princess of Wales**, Bryan Organ, 1981
- **Self-Portrait**, Chris Ofili, 1991
- **Germaine Greer**, Paula Rego, 1995
- **A.S. Byatt**, Patrick Heron, 1997
- **J.K Rowling**, Stuart Pearson Wright, 2005
- **Catherine, Duchess of Cambridge**, Paul Emsley, 2012
- **Ed Sheeran**, Colin Davidson, 2016

Notes

First published by Unicorn,
an imprint of Unicorn Publishing Group LLP, 2019
5 Newburgh Street, London W1F 7RG

www.unicornpublishing.org

10 9 8 7 6 5 4 3 2
ISBN 978-1-912690-45-9

Design: Felicity Price-Smith
Printed in the EU on behalf of Jellyfish Solutions